Amsterdam

Sketchbook

To:
Margot
On Your 70th Birthday.
With Best Wishes from
Graham Byfield

27th September 2008

Paintings © Graham Byfield 2008
Text © Hinke Wiggers 2008
Design and typography © Editions Didier Millet 2008

Captions and text translated
from the Dutch by Gregory Bracken

Editorial Director: Timothy Auger
Editor: Ibrahim Tahir
Designer: Tan Seok Lui
Production Manager: Sin Kam Cheong

First published in 2008 by
Editions Didier Millet
121 Telok Ayer Street, #03-01
Singapore 068590
www.edmbooks.com

Colour separation by Colourscan Co. Pte Ltd, Singapore
Printed by Star Standard Singapore

ISBN 978-981-4155-99-1

ARTIST'S ACKNOWLEDGEMENTS

When asked by my publisher and good friend Didier Millet to sketch this elegant city,
I wondered how I could do everything well enough to follow in the footsteps of some of the
famous painters who have recorded Amsterdam over the past centuries.

However, I am indebted to Hinke Wiggers for her expert knowledge and enthusiasm for the city
and guided me to some hidden gems. And to my patient editors Tim Auger and Ibrahim Tahir who
have coordinated this sketchbook admirably.

I hope we have been able to do justice to Amsterdam's history and beauty.

Amsterdam
Sketchbook

Paintings by Graham Byfield Text by Hinke Wiggers

Editions Didier Millet

Contents

Introduction / Page 6

Oude Zijde / Page 20

Nieuwe Zijde / Page 30

From Brouwersgracht to Rosengracht / Page 40

Around Leidsestraat / Page 52

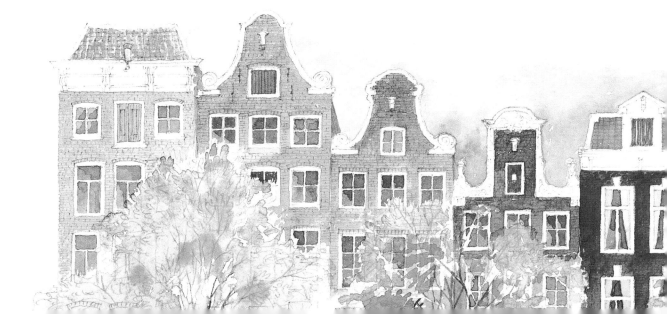

Around Rembrandtplein and Vijzelstraat / Page 64

IJ, Amstel and Plantage / Page 74

Museum Quarter and Vondelpark / Page 82

Gazetteer / Page 90

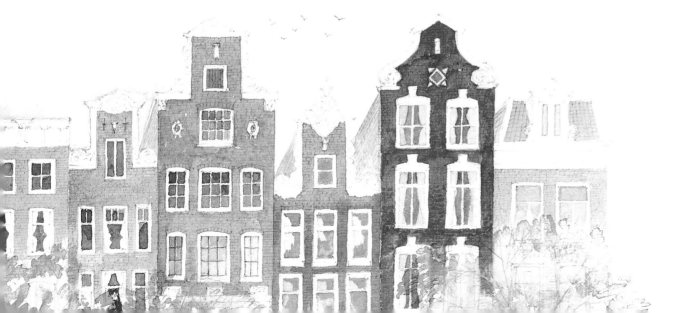

Introduction

Commuters, tourists, daytrippers—huge numbers stream through Amsterdam's Central Station. Many hop straight onto trams, while others head into the city by foot. After crossing the bridge in front of the station they are on the very spot where for centuries visitors to Amsterdam have stepped ashore. During the Netherlands' Golden Age in the 17th century, a visit to this celebrated merchants' city must have been an amazing experience. Many sailed across the Zuiderzee into the harbour, where countless ships lay at anchor. The great expanse of the city could be seen stretching along the quayside—tower after tower, warehouse after warehouse, canal after canal. This is a city without castles or palaces, but with a rich civic history.

Here, the citizens themselves created a mighty 'Venice of the North' out of nothing but marshy bog. Land had to be reclaimed, but because of increasing pressure on space in the higher-lying parts of the country, settlers moved into the bogs and fens of Holland in the 11th century. Farmhouses were built on drained and raised ground, and at the delta of the River Amstel, settlers created a village in the fens in around 1200.

Flooding was a constant threat. The IJ, a natural harbour, was linked to the North Sea via an inland sea. The ground was sinking because of natural soil compaction after reclamation, so a seadyke, and dykes along the Amstel, were built as well as a dam. A lock in the dam functioned as a sluice-gate. The construction of the dam was an important step towards urbanisation, uniting the settlements that grew up on the two banks of the Amstel into one village. The Amstel and the dam gave Amsterdam its name. The first recorded mention of the settlement was in 1275, when it was noted that the 'folk that live in Amstelledamme' were granted the right to transport their own goods free of any toll imposed by the Count of Holland.

A century later, the village on the Amstel had become a small city. In the meantime, it had been granted municipal rights and the citizens had built a charming parish church on Oude Zijde, to replace a simple chapel. City walls, the feature of many medieval cities, did not exist in Amsterdam, although earthen defences ringed the city until 1482. Why did Amsterdammers take so long to erect a stone wall? Perhaps there was not money enough to fund it, stone being rather costly. The city had been extended to the east and west by digging canals and building wooden houses on the dykes that were raised alongside them. In an effort to counter the danger of fires, these were not allowed to touch one another. The most important streets were Nieuwendijk on Nieuwe Zijde and Warmoesstraat on Oude Zijde, which were crossed by many lanes and alleyways, which were formerly ditches.

Most of the city's economic life was to be found on Nieuwe Zijde. The increase in the number of people there made a second parish church necessary, the Nieuwe Kerk (New Church). This, however, went up in flames in 1421, after which it was rebuilt. A second big fire in 1452 was so ferocious that it left only a third of the city standing. The reconstruction that followed saw the beginning of the 'stoning' of the city. Houses had to have stone firewalls at the sides, and roofs of tile or slate.

An important step in Amsterdam's development as a trade centre was the levying of a beer toll on what was known as 'Eastern' beer in 1323. This beer came from Hamburg and was made from hops, which made it far tastier than anything made locally. Ships bringing beer from Hamburg were obliged to call at the port of Amsterdam and pay their toll before local vessels carried it further south. The beer toll led to the growth of trade with the coastal cities of Germany as well as those of the Baltic. Amsterdam initially traded in cooperation with the Hanseatic League, even waging war with the Hanseatic cities in 1368 against the Danish king who had closed off the Sont, the

Central Station, built on a man-made island first opened for train traffic in 1889. The location of the station brought about angry reactions as the building shut off entirely the view of the harbour from the City. Although there are still Amsterdammers who regret this, the convenience of having a station in the city centre is generally acknowledged.

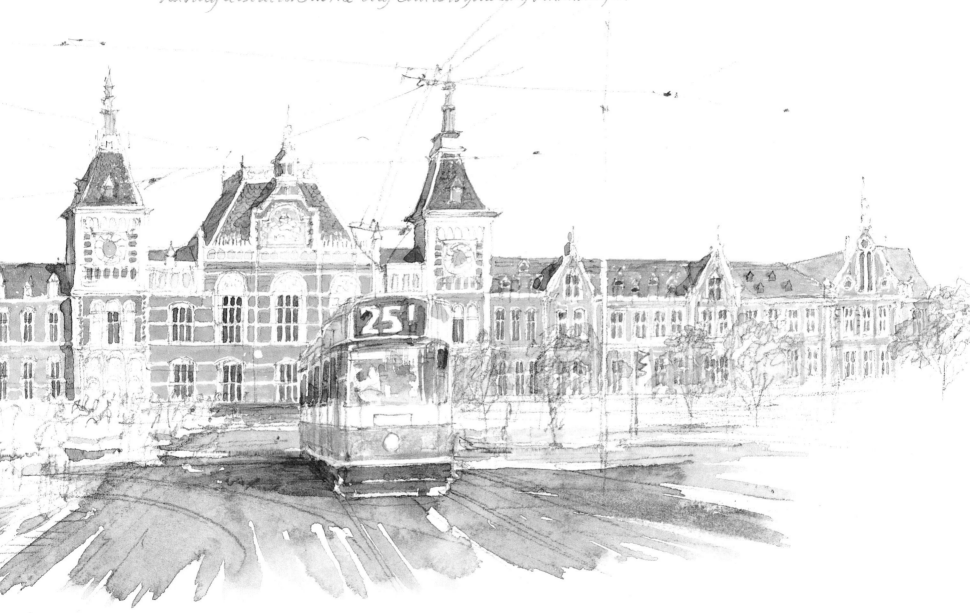

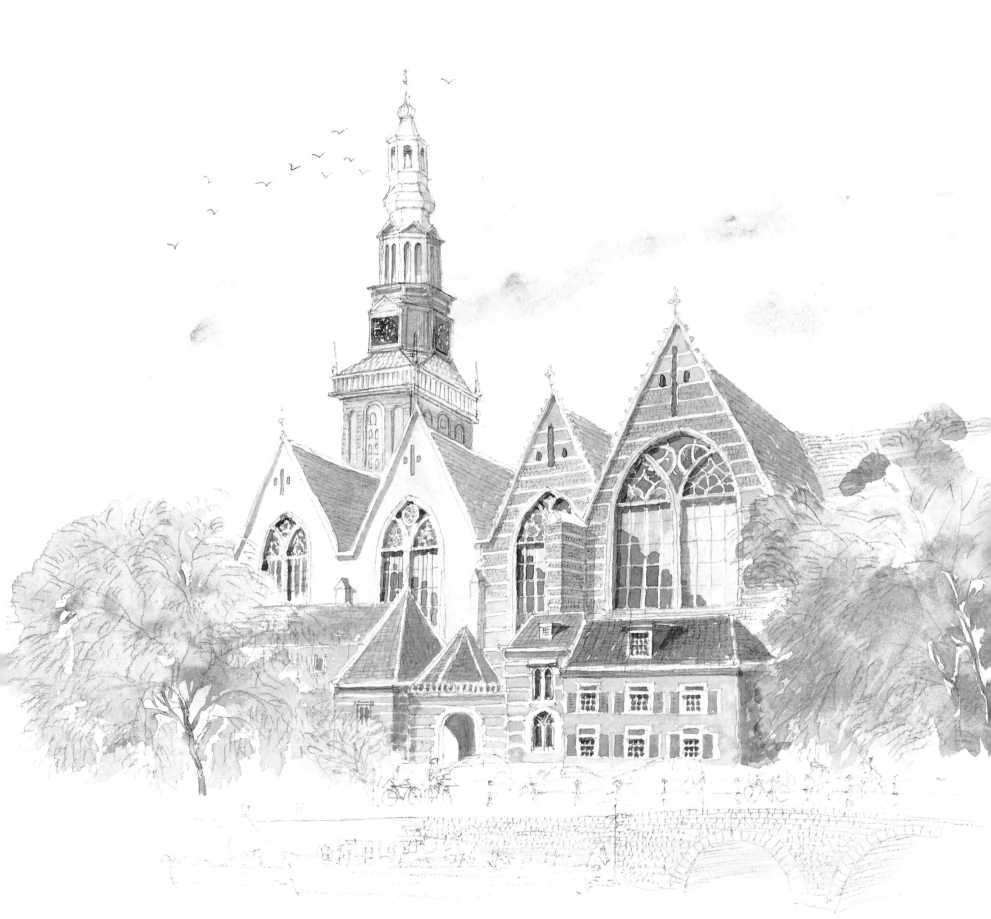

narrow strait between Denmark and Sweden that is the only entry to the Baltic Sea. Soon the League's rules, which prescribed who brought and fetched what products where, became too restrictive. Amsterdammers then began exploring the abundant trading possibilities of the Baltic Sea on their own. In the beginning, the ships brought herring to the Baltic and returned laden with grain. Many other products found their way into Amsterdam's warehouses, but within this trade network, grain and herring remained the most important. The Baltic trade continued to be the source of Amsterdam's prosperity for several centuries.

Trade, as well as activities such as shipbuilding, the textile industry and soap-making, brought newcomers to the city, where it soon became clear that another extension, which included the Singel area ('singel' is a Dutch word for a kind of city moat), was needed. But the largest project in the 15th century was the building of the city wall, necessary at the time because of political unrest in the country. The wall, which was five to six metres high, was completed by around 1490. Five gates allowed entry to the city, which now covered 80 hectares, and by 1560 was home to about 27,000 inhabitants.

Amsterdam now functioned like a well-oiled machine with the Dam at the heart of city life. Here stood City Hall, where four burgomasters, chosen annually, had their seats. They took care of daily government and were advised by a council of city fathers and a bench of aldermen. The administration of justice was in the hands of a sheriff, assisted by the aldermen. To guard against danger there was a civic guard. All these men, including the civic guard, were drawn from a small group of wealthy to very wealthy families, who were closely related. Needless to say, they passed each other the plum jobs. Burgomasters, aldermen and city fathers were indeed chosen, but by themselves and from among themselves. They were powerful, although for the time being, only at a local level. They could not

protect Amsterdam from the sweeping changes that occurred throughout Europe in the 16th century. In the field of government, absolutism had begun to make inroads, while in the religious sphere, the reform ideas of Calvin and Luther were gaining ground amongst the adherents of Catholicism, which hitherto had been the predominant Christian doctrine.

Holland, of which Amsterdam was part, became a province in a huge realm. Charles V, of the Habsburg dynasty, Emperor of Germany and King of Spain, had also gained supremacy over the 17 Dutch provinces (present-day Belgium and the Netherlands). He sought to unify the whole area, establishing in 1531 a central government in Brussels, and appointing stadholders, all noblemen, in every province. Then in 1555 his son Philip II took the throne of Spain and the Dutch provinces. Philip was a devout Catholic who saw it as his duty to suppress dissenters, which he did by fire and sword.

Unrest in the provinces grew. Calvinism was increasingly popular but was harshly repressed by the central government. Noblemen, among them the stadholders, made their protest in Brussels. They asked for a softer approach to heretics and for some say in the government. Cities had to deal with a restive population. Coupled with a serious economic malaise, a *Beeldenstorm*, or iconoclastic frenzy, was unleashed in 1566. Calvinists and their sympathisers plundered Catholic churches, overturning altars and destroying holy images. Philip II did not budge an inch. Worse, he sent the Spanish Duke of Alva—the 'Iron Duke'—with his Spanish army to bring the situation in the provinces under control.

In 1568 the provinces rebelled against the central government in Brussels as well as the hated Duke of Alva. Spearheaded by Prince William of Orange, the uprising spread from city to city, and from province to province. The unrest was felt in Amsterdam, which had twice endured *Beeldenstorms*. When it became known that the Duke of Alva was on his

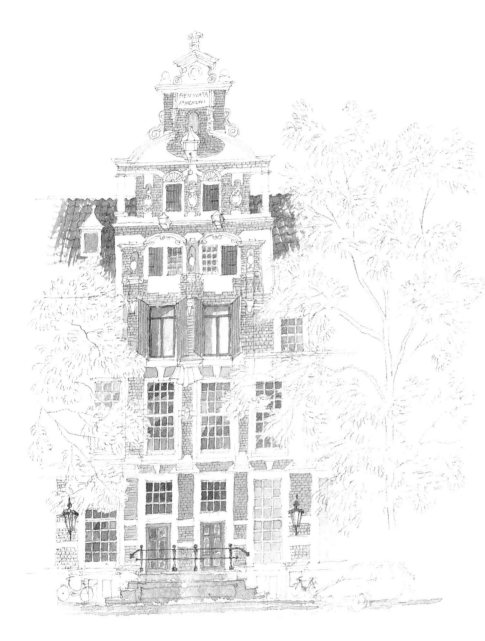

The Bartolottihuis is a spectacular, richly decorated canal palace on the Herengracht. The building was named after its builder, Guillelmo Bartolotti, who moved into the house around 1618. Nowadays it is the home of the Theater Instituut Nederland.

way to Brussels, there was an exodus from the city. Calvinists and their sympathisers, and indeed anyone who had been part of the opposition, fled. This was enormously damaging to Amsterdam's economy because many of the financially powerful were among the refugees. Protestants who remained were put to the death, condemned by the Duke's 'Blood Committee'. With all opposition either in exile or dead, the Catholic city council was again firmly in charge. Amsterdam did not join in the ensuing rebellion, not even in 1572, when most of the cities of Holland and Zeeland backed the Prince of Orange and recognised him as their Stadholder. That Amsterdam had remained true to the King of Spain, the Duke of Alva and Catholicism was to have catastrophic consequences.

Lying as it did at the entry point to the province of North Holland, Amsterdam was needed logistically by the Spanish so that they could lay siege on the city of Alkmaar, among others. The 'watergeuzen' (as the seaborne rebels were known) hijacked a trade fleet of 50 ships from Amsterdam, which had just returned from the Baltic. This was a blow for the city. The situation lasted until 1578, ten years after the uprising began.

A revolution was necessary. The civic guard expelled the four Catholic burgomasters, sending them out of the city on a boat, and elected from among themselves Calvinist burgomasters and formed a council. The Oude Kerk (Old Church) was cleared of its altar and holy images and was made ready for Reformed services. This revolution became known as the 'Alteration' and heralded the start of Amsterdam's famous Golden Age.

From 1578 to around 1650 the city enjoyed unprecedented prosperity. The uprising had in fact created conditions for economic growth. In 1579, the seven northern provinces agreed to be 'united till eternity, as if they were one province, each keeping its own specific rights and privileges'. A tiny country was born, a federation in which the cities could determine their own

Nearly every house in Amsterdam, such as this one in the Begijnhof, has a hoist beam, like the warehouses. They are especially used when moving house because staircases in these houses are mostly very narrow.

policies. It was, however, still at war with Spain, a great power; and it did not have a monarch, something unheard of at that time in Europe. After some years, it became clear that this small country was able to carry on without a monarch, and so it became the Republic of the Seven United Provinces, a republic where the cities enjoyed the fullest measure of self-government.

After the 'Alteration' many who had fled returned. Amsterdam had become a Calvinist city; the burgomasters had confiscated all the possessions of Catholic institutions and gave them to charitable organisations such as hospitals, orphanages and old-age homes. Public expressions of the Catholic faith were banned and Catholics, as well as people of other faiths, were denied any say in government. While the southern provinces continued to suffer during the uprising, here its fruits were being enjoyed. In 1585 the important harbour of Antwerp fell into Spanish hands. Zeelanders and Hollanders closed the Schelde, the waterway that serves as the entry to the port of Antwerp. As a result, Amsterdam became the most important port in the region. People fled the war zone to establish themselves in the northern provinces and a large majority came to Amsterdam. They brought their riches, as well as their trade contacts and specialised skills. Traders, printers, academics, all were welcomed with open arms, and contributed greatly to Amsterdam's prosperity.

Meanwhile, Philip II had also become ruler of Portugal, which brought, among other products, pepper from Asia, where the Portuguese had a trade monopoly. Because import of these products stagnated, Hollanders and Zeelanders decided to exploit Portugal's trading area for themselves. To avoid clashing with the Portuguese fleet, they first tried an alternative route to Asia across the North Pole. When this failed, they had to resort to using the Portuguese route around Africa. The first fleet returned successfully from Asia, and despite having suffered heavy losses it at least had pepper on board.

Beautiful Amsterdam on a quiet autumn day. Here is where the Keizersgracht and Reguliersgracht meet. In 1900, Amsterdammers prevented the filling-in of the picturesque Reguliersgracht.

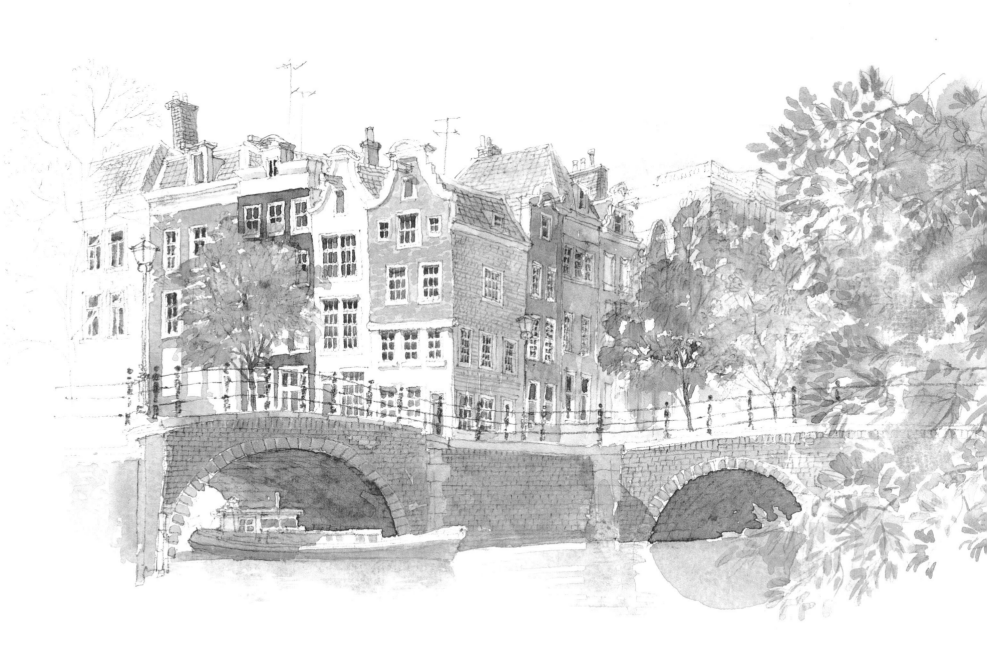

Once they had got a whiff of this lucrative trade, the Dutch merchants were not going to be stopped by the Portuguese. In order to spread risk and to regulate the sailings as well as the trade, the Verenigde Oost-Indische Compagnie (VOC) (Dutch East India Company) was founded in 1602. VOC chambers were established in Amsterdam, Middleburg, Rotterdam, Delft and Enkhuizen. Amsterdam was supplying most of the ships as well as a large part of the capital for the VOC. Before long, the VOC had established trade outposts and began to annexe settlements all over Asia. It became the largest trade organisation in the world; and following this success, the West-Indische Compagnie (West India Company) was founded in 1621.

The rapidly growing prosperity of Amsterdam, where products from all corners of the world were stored, and whence they were carried to the rest of the world, attracted a huge number of immigrants. At the end of the 16th century, Spanish and Portuguese Jewish families established themselves here, and from around 1630 Jews began to arrive from central and eastern Europe. Others followed: Norwegians, Danes, Armenians, English, French and above all Germans. Many Germans. Amsterdam had become a multicultural city, governed by a Calvinist elite who would not allow dissenting thoughts in their midst. But as a people who had become wealthy through trade, and by letting the interests of trade prevail, they saw advantages in this stream of newcomers. The disadvantages (not every newcomer was or would become wealthy; and as general prosperity grew so too did the army of the poor) they accepted as part of the way things were.

There was plenty of work in the city. Thousands worked in the VOC and marine shipyards in the good times, while the breweries and sugar refineries needed many hands. And the logistics—weighing and measuring all the goods—were also labour-intensive. Most professions were organised into guilds: there were, for example, guilds for bag carriers, corn measurers, and surgeons.

A lot more work was generated after 1613 when it was decided to extend the city due to the rapid population growth. A comprehensive plan for urban renewal provided for a hierarchical system of canals with mathematical relationships between them, their quays and their plots. The layout ignored the existing agricultural pattern of paths and channels, by which Amsterdam had been ringed since its earliest days, and which was generally followed when being built on. These spacious new canals were intended to house the city's elite. Over to the west another area came into being, one that did not exhibit this mathematical precision and one where the existing agricultural structure was followed: the Jordaan, a district for the middle classes, craftsmen and other petit bourgeois. It was a gigantic undertaking, especially in 1657 when the canals were extended to the east of the city, thus creating the city's characteristic half-moon plan, as well as the broad and inviting harbour front. At the end of the 17th century, the city had tripled in size, and was surrounded by a high wall, regularly divided by 26 bastions, with a windmill on every bastion. No matter where you were in the city, you could nearly always see a windmill.

In the mid-17th century another great building project came into being, almost as spectacular as the canal ring, one that must have provided the high and mighty in City Hall with as much satisfaction. The City Hall then was a charming little Gothic building that had become dilapidated and was far too small. Plans were made for a new City Hall on the western side of the Dam, something that would announce to the world that this was a rich city. Master builder Jacob van Campen designed a symmetrical, neoclassical building of unprecedented dimensions.

Amsterdam was now at its apogee, the trade and financial centre of the world, and a hub of culture and knowledge. Many great painters, including 17th-century Dutch masters such as Rembrandt van Rijn, who

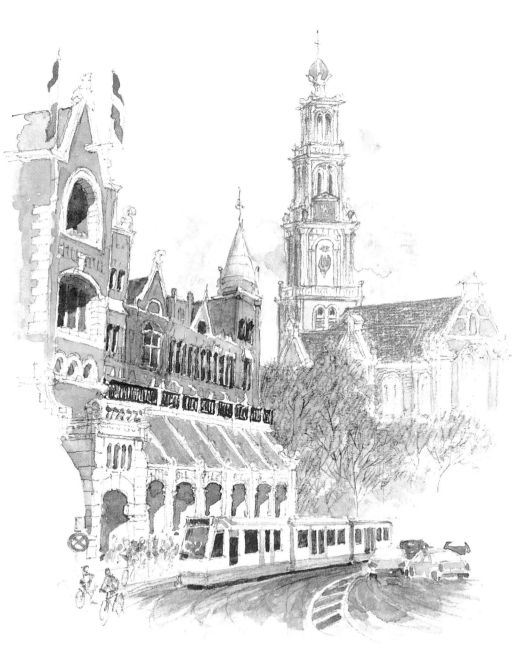

Immediately after the filling-in of Raadhuisstraat at the end of the 19th century, this slightly curved shopping gallery was erected. The area has a somewhat 'boulevard' ambience. In the background is the 17th-century Westerkerk (Western Church) on the Westermarkt (Western Market), with its 85-metre tower, the highest in Amsterdam.

originated from Leiden, received their greatest commissions during this period. Proud group portraits—of councillors, surgeons, governors of charitable institutions—and the family portraits of the elite also date from this period. Merchants brought home not just trade goods from far-off coasts but also exotic plants, fruits, animals and all kinds of other items that had attracted their curiosity. Knowledge of previously unknown parts of the globe increased. Amsterdam had the best cartographers. There was freedom of the press (critical foreign writers had their books published here), and freedom of worship—except for the Catholics.

Sir William Temple, the first British Ambassador to the republic, wrote in 1673: 'The United Provinces are the envy of some, the fear of others and the wonder of all their neighbours.' The previous year, the country had been under siege from all sides, almost trampled on by Germans, English and French. Trade restriction measures were put into place, particularly by England and France. At sea, the republic had to establish supremacy over England, and this was achieved through a series of bloody sea battles. For the time being, the republic ruled the waves.

Even after the great period of growth had ended, Amsterdam remained an attractive city for immigrants in the 18th century. It was a well-organised city too, with an extensive support system for the needy. And it remained quite independent: functioning almost as a state within a state, its government was still in the hands of a small group of rich governors. But as the century wore on, rumblings were heard in the republic. To counterbalance the centrally governed great powers of France and England, the calls for reform were getting louder. There was a critical civil movement, the 'Patriots', who strove for political power in the country and in the city. Influenced by the American struggle for independence and the French Revolution, the differences between these Patriots and the

Pillars with colourful posters stuck on them are to be found everywhere in Amsterdam. The are called what can be literally translated as "Pepper Pots", and actually house electrical transformers.

governing parties grew ever greater. The Patriots asked the French army for help. The government's army could offer no effective resistance and the stadholder fled to England. In 1795 a more modern government body came into being, and the citizens got equal rights: the Batavian Republic was formed. The stadholder and many of the governors had fled, but the French were in, and in they stayed. They wielded so much influence that they were able to establish, in 1806, a monarchy in place of the republic, the Kingdom of Holland, with King Louis-Napoleon, brother of the French emperor, as king. Four years later, the kingdom was annexed by the French empire.

These events had huge consequences for Amsterdam. The city lost its power. The English were masters of the sea, so shipping was languishing, and the already bad economic situation continued to deteriorate rapidly. The staple-market function of the city was fast diminishing. And the city hall, that pride of Amsterdam, the world's 'eighth wonder', became home to King Louis-Napoleon. But not for long. With defeat at the Battle of Leipzig in 1813, the French emperor's reign in Holland came to an end. The Netherlands became the Kingdom of the Netherlands, now under the country's own royal family, the House of Orange, related to that first Prince of Orange, William I, leader of the Uprising.

The French left Amsterdam, indeed the whole country, in a deplorable condition. The power and glory were gone from the city, and it now had to adjust to a new role: capital city, of a small country. Amsterdammers looked hopefully to their harbour. That was where the wealth used to come from. But the past could not be repeated. Slowly Amsterdam worked towards economic recovery. The harbour had begun to silt up, but this was alleviated by the construction in the harbour of two dykes in the east and the west. The digging of the Great North-Holland Canal, from Amsterdam to Den Helder, was undertaken to eliminate troublesome journeys over the Zuiderzee, with its treacherous shallows. It was an enormous undertaking. At its completion in 1824, it was the longest canal in Europe, but it did not make much difference in the end. The age of the steamship had begun, and these increasingly large ships could make little use of this narrow canal.

Initially, not much was done to the city, which was in serious decline. The working-class neighbourhoods of the Jordaan and the Eastern Islands continued to deteriorate. Amsterdam was slumbering inside the old city walls. No extensions had been made for a very long time. The spacious 17th-century extension had left enough space for everyone. This introverted city was still living in its glorious past when, in 1840, a new city gate was built to replace the old ramshackle one. Not long afterwards, beside this gate, known as the Haarlemmerpoort, a station building was erected, to be the point of departure for the steam train to Haarlem.

With the dawning of the era of steam power, some building activity got underway, which kick-started the economy. The Paleis voor Volksvlijt (Palace of Industry), following the example of the Crystal Palace in London, and the Amstel Hotel were the pioneers. The North Sea Canal ushered in this new era. In part due to the shortcomings of the Great North-Holland Canal, an old plan was revived: a canal that would run directly from Amsterdam to the North Sea coast, a distance of about 26 kilometres. After much difficulty, the canal was finished in 1876, and fulfilled all its expectations. Amsterdam had entered its second 'Golden Age'.

Amsterdam had also begun to demolish buildings and fill in canals. The pattern of medieval and 17th-century-era streets, lanes and canals were unsuitable for modern life, with its increasing number of horse-drawn trams, coaches, cyclists and heavily laden wagons. It was also

difficult to get from the new surrounding areas into the old city. While banks, insurance companies—anything with an office—established themselves in the old city centre, residents were moving out. Some Amsterdammers cast jealous eyes towards Paris. There the entire medieval city had been demolished and space was made for beautiful, wide boulevards. Amsterdam didn't go quite that far. The canal ring was only broken through in one place—behind the Royal Palace an arterial road was created leading to the west. Raadhuisstraat and Rozengracht, two canals that had run in that direction were filled in.

Towards the east, where in a very short time a working- and middle-class neighbourhood would establish itself, some of the houses were so poorly built that they fell down before they were even finished. Leidsestraat, the route to the south where a chic neighbourhood had built up around the Vondelpark, was left undisturbed. Here, even today, the trams still have only one track, with stops on the bridges so that they can pass one another.

It was during this period that most of the city's signature buildings were constructed, such as Centraal Station, on a man-made island in the IJ; and the Beurse (Stock Market) of Berlage, for which part of Damrak was filled in. The de Bijenkorf department store was able to acquire a prime location facing Dam Square, in a building that could compete with the 17th-century City Hall, their neighbour on Dam Square and now the Royal Palace. On Leidseplein the fashion department store Hirsch & Cie, was built on a scale never seen before. Not far away was the recently completed Rijksmuseum (State Museum), with its two towers and passageway that look like a huge city gate—a gate to art and culture. The Catholics, who since the French occupation had again been able to profess their faith publicly, caught up remarkably quickly. One after another, imposing churches were erected, notably the Sint-Nicolaaskerk (Saint Nicholas Church) opposite Centraal Station.

This glittering city attracted many of the curious, as well as newcomers and fortune-seekers. Just as in the 17th century, there was a favourable cultural climate. Passionate young painters such as George Hendrik Breitner and Isaac Israels came to live here—not to paint portraits of the rich city fathers, but rather to paint the ordinary life of the city. Visiting artists, including Claude Monet and Max Liebermann, were gripped by its picturesqueness.

In the Jordaan and Uilenburg, the latter area being home mainly to Jews, people had to cope with miserable living conditions. There was a need for good-quality, affordable housing. At the beginning of the 20th century, building plans were prepared but were suspended when World War I broke out. Despite the fact that the Netherlands remained neutral, the war still affected the country. The prime concern of the Amsterdam government was the distribution of food and not with the building of houses. In 1917, building was started on the other side of the IJ, the first time that the city of Amsterdam built houses in what was a rural area dotted with little villages. People from the Jordaan were able to come here to live. In the east, the Transvaal neighbourhood replaced the newly demolished Uilenburg, and in the west, the Spaarndammerbuurt was built. Residential building had always been a private initiative, but times change. The majority of the houses were now built by housing corporations using government subsidies, partially funded by the community; only a very small proportion were put up by private enterprise. A lot of care was taken with public housing at this time, when the social-democratic ideals of elevating working people were prevalent. The output of what became known as the Amsterdam School was quite beautiful. Houses were constructed with pretty curves and decorations, and laid out around squares, in a semi-circular or courtyard form.

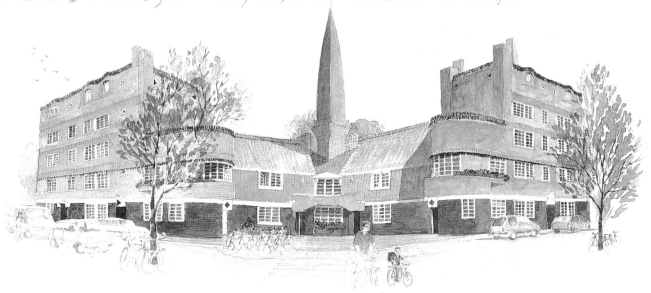

The land area of Amsterdam had now nearly quadrupled and the number of inhabitants had risen to 680,000. This enormous growth was partly the result of Amsterdam having engulfed villages that lay to the north, on the other side of the IJ, and by the annexation of other areas. In 1928 Amsterdam hosted the 9th Olympic Games, for which an Olympic Stadium was built in the south of the city.

Then Amsterdam's second 'Golden Age' ended. The world fell into a deep economic crisis after the American stock market crash in 1929. Unemployment grew to alarming proportions worldwide. Amsterdam had, after only two years, 35,000 unemployed, 20 per cent of the working population. The unemployed received financial support via the municipalities, but not everybody qualified. The government cut back on these social security benefits for 24,000 people who could only just afford their rent or a scanty daily meal. In 1934 the situation turned explosive. The unemployed moved into the Jordaan, where they rioted against the police. The following day the unrest spread to all other working-class neighbourhoods. The army was called in to quell the uprising, resulting in six deaths and many wounded. After the Jordaan incident, the unemployed accepted their unfortunate lot. Throughout the whole country, the unemployed were put to work on large-scale projects where they had to earn their assistance money. In Amsterdam, one such project was the Amsterdamse Bos, which is now a place for jogging and picnics.

The crisis years were fertile ground for national socialism. After occupying Poland, Nazi Germany attacked the Netherlands on 10 May 1940. On 15 May German soldiers marched through Amsterdam. The Dutch government had capitulated after a brutal bombardment of Rotterdam. The Amsterdam municipal council 'officially' welcomed the German commander in City Hall. This was an occupied city. World War II was to have enormous consequences for Amsterdam—not so much in a material sense (the city was at least spared the fate of Rotterdam, which was flattened by bombs), but in the loss of many lives. Amsterdam was the city with the largest Jewish community in the country. Immediately after the occupation, restrictive measures were implemented against the Jews. Then began the raids by the German occupiers. The first was on 22 February 1941: more than 400 Jewish men were deported. A day later the same thing happened again. Two days after that, a massive protest broke out. Out of solidarity with their Jewish fellow citizens, the outlawed Communist Party called for strikes. Thousands put down their tools and

On Prins Hendrikkade stands the impressive Scheepvaarthuis, built in 1916 for six Amsterdam shipping companies. It was the first building to be built entirely in the Amsterdam School style. Many well known artists worked on the ornamentations.

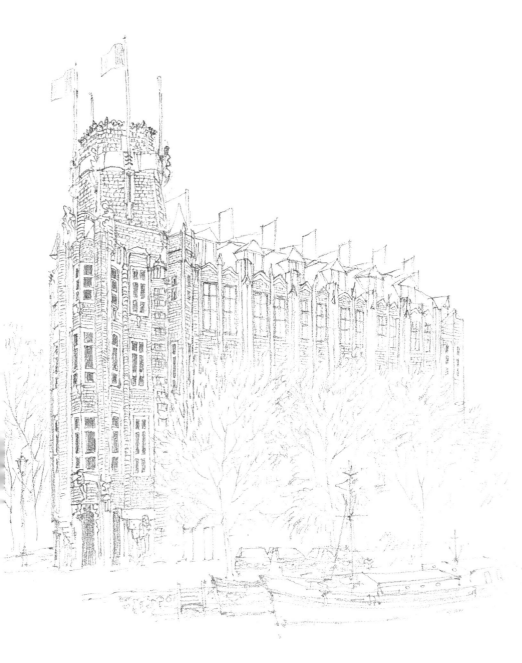

marched into the city. The protest lasted two days and was brutally suppressed. This February Strike, as it became known, took on great symbolism after the war and is still commemorated every year.

After the February Strike one anti-Jewish rule was imposed after another. Signs with the words 'Forbidden to Jews' began to appear, and Jews were forced to wear the Star of David. The first systematic deportations occurred in 1942. By the end of the war, less than 15,000 of the city's Jewish population of 80,000 (in 1941) had survived.

In 1944 the Allies had got as far as the Netherlands, even though they were brought to a standstill by the abortive attack on Arnhem. The south of the country was liberated, while the north became very isolated. In Amsterdam the supply of goods, especially food, which came by rail, was cut off. Through the extremely harsh winter that started in December, the shortage of food and heating materials became almost intolerable. During this 'Hongerwinter' (Hunger Winter) nearly 6,000 people died. Finally, on 5 May 1945 the surrender was signed and the northern part of the Netherlands could celebrate with their liberators. Two days later, the citizens of Amsterdam were gathered to welcome the Allied army into their city for a great celebration on Dam Square. German sailors, who had holed up in a building there, opened fire on the masses; 22 were killed and more than 100 wounded. The following day the war was really finally over for Amsterdam: the Canadians entered the city via the Berlagebrug (Berlage Bridge), cheered by people beside themselves with joy.

Life was totally disrupted; there were shortages of everything, particularly raw materials. The war had left holes in the city, made largely by the people themselves as they looked for things to burn so they could fill their stoves. The areas where the Jewish citizens of Amsterdam had lived were plundered during the Hunger Winter. The need for housing was dire.

The Anne Frank House on the Prinsengracht was where the Frank family hid during World War II. It was here that Anne Frank wrote her famous diary.

Amsterdam in the 1950s was a hard-working, bourgeois city. In the mid-1960s this totally changed. It became lively, even rebellious. This change came from the youth, many of whom did not take authority seriously. The first to make themselves heard were the Provos, an anarchistic, peaceful organisation. With their playful actions they highlighted social problems and came up with unusual and sometimes futuristic solutions. They held weekly 'Happenings' on the Spui, near the Het Lieverdje statue, given to Amsterdam by the Hunter tobacco factory, and what the Provo proclaimed was the symbol 'for the addiction of the consumers of tomorrow'. The Happenings were all designed to provoke the authorities, who didn't know what to do: there were arrests and confiscations, and crowds were broken up. The Provos existed for two years, and in that time did a lot to shake up society. Anti-establishment thinking was here to stay, and one action group after another made it to the headlines, including the Dolle Mina's (Mad Minas), a radical feminist group who fought for abortion rights, and the squatters.

The decades after the war were a time of thrift and hard work, in which appeared what became known as 'Garden Cities', part of the huge Algemeen Uitbreidings Plan (General Extension Plan), drawn up in the 1920s. Its watchwords were 'light', 'air', 'space' and 'greenery'. There were no expensive materials, decoration or overtly artistic buildings, such as had been built by the Amsterdam School architects. Just slabs of housing blocks, three to four storeys high, with large windows to let in plenty of sunlight and wide green zones between them. Dedicated tramlines were laid down on wide radial streets, their capacity allowing for future growth in traffic.

This reconstruction was accomplished surprisingly quickly, and by the 1960s, there were the beginnings of a thriving consumer society. 'Ordinary' people could now afford luxury products, including cars. The city centre of Amsterdam was quite unsuitable for this explosion in car use. Again there were proposals to fill in the canals, which stood in the way of traffic. The protest was huge: the canals stayed. Amsterdam now has one of the most important and intact historic city centres in the world, and the 17th-century canal ring has a unique place in this. The traffic problem remains controversial—banning cars from the city centre is vehemently opposed by retailers and others who are established there.

Today, the roaring years may have gone, but Amsterdam has not gone quiet. With 750,000 inhabitants, approximately half of whom have come from other countries across the world, Amsterdam is a real cultural melting pot. Little by little the city and its citizens are learning how to deal with this new partnership, one that has come about in a very short time.

However, the past should not be forgotten. Amsterdam has rediscovered its harbour, which had in recent years begun to look a little sad. It is central to the cultural resurrection on the banks of the IJ, where many new houses, recreation and work spaces are beginning to spring up, often with striking architecture. Water transport is being stimulated, and there is a new call for an open harbour front. This is where the eyes of Amsterdam are now turning. The city has come full circle.

Oude Zijde

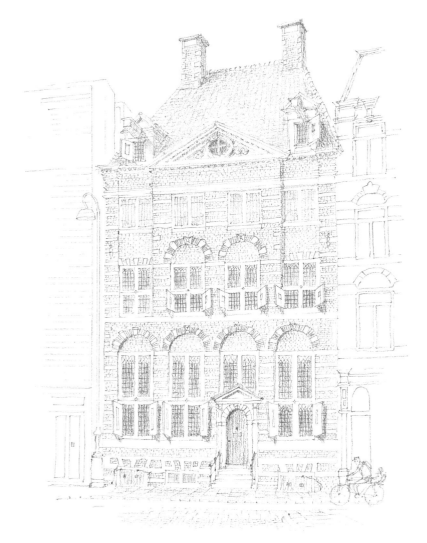

Rembrandt lived, and painted his most beautiful works in this lavish house. It is now the Rembrandthuis Museum.

Despite its name, Oude Zijde (Old Side) is no older than the Nieuwe Zijde (New Side). The names originated when a second church was built on the Nieuwe Zijde; the first church became known as the Old Church and the second one as the New Church. Here also are most of the city's medieval monuments.

Warmoesstraat, a chic street until the end of the 16th century, was where many merchants were established, including the all-important grain traders. Behind their homes they built warehouses, which stood on the Damrak. Most of the city's monasteries were established here, although they were dissolved following the 'Alteration' of 1578. With all its cafés and restaurants, not to mention the Red Light District, it is hard to imagine that this used to be an area of great religious devotion.

The Waag, on Nieuwmarkt, was originally a city gate, the Sint-Antoniespoort (Saint Anthony's Gate) that dates from 1488. It was then turned into a 'waag' (weigh station) for goods, with space upstairs for some guilds. In the 19th century the Waag was, among other things, used as a place of execution. In the 20th century it was home in turn to the City Archive, the Amsterdam Historical Museum and the Jewish Historical Museum. A daily market now makes the square as lively as it was in earlier centuries.

To the east, Oude Zijde merges with the old Jewish neighbourhood, or Nieuwmarktbuurt. At the beginning of the 17th century, Spanish and Portuguese Jews established themselves here, later to be joined by Jewish fugitives from eastern Europe. In 'Mokum', as they called Amsterdam, they were not persecuted because of their faith. On Jonas Daniël Meijerplein stands the proudest expression of this freedom: the Portuguese Synagogue. Built in the 17th century, when it was the largest synagogue in the world, it is home to the Ets Haim Library, which is of inestimable value for the study of Judaism.

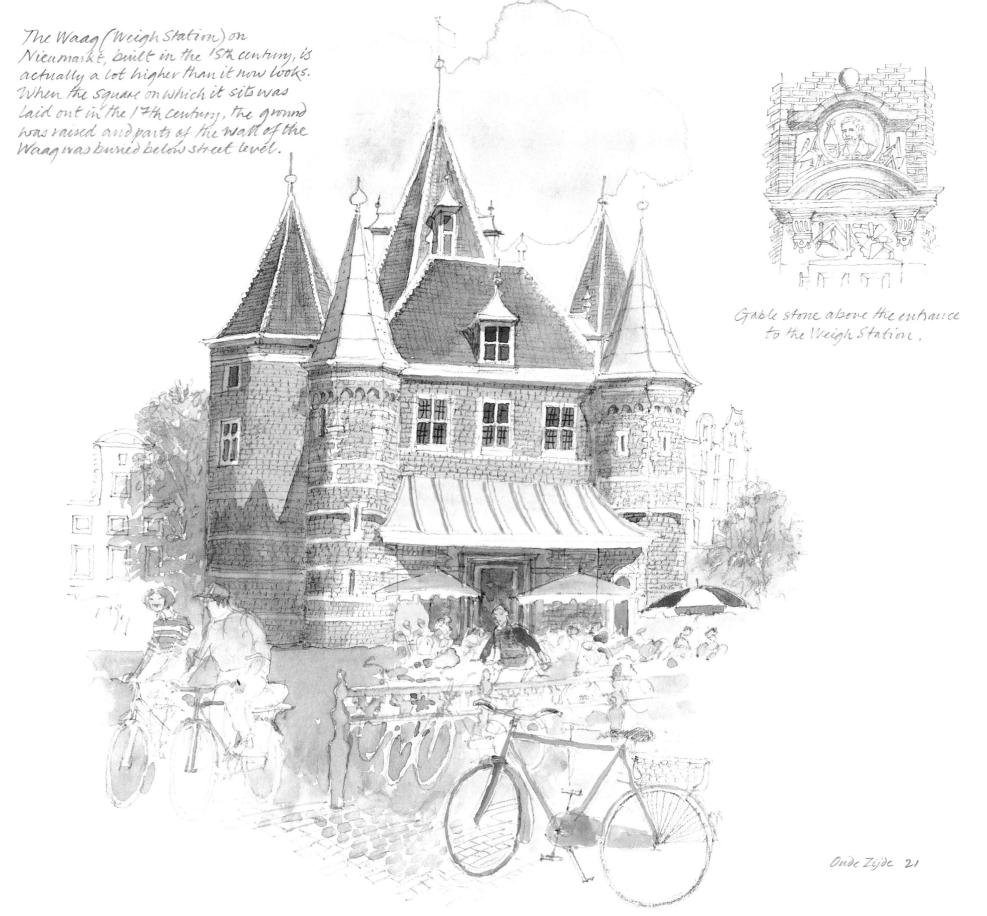

The Waag (Weigh Station) on Nieuwmarkt, built in the 15th century, is actually a lot higher than it now looks. When the square on which it sits was laid out in the 17th century, the ground was raised and parts of the wall of the Waag was buried below street level.

Gable stone above the entrance to the Weigh Station.

Oude Zijde 21

The building that now houses Sofitel The Grand hotel is known to Amsterdammers as the Prinsenhof (Princes' Court), because in earlier days the princes of Orange and visiting foreign sovereigns were lodged at this site. From 1808 to 1988 the Prinsenhof was the seat of the municipality.

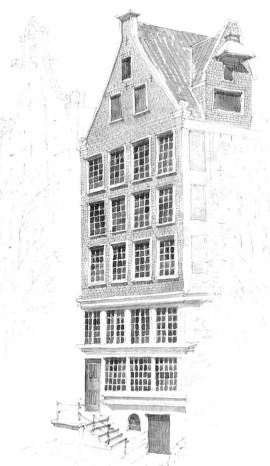

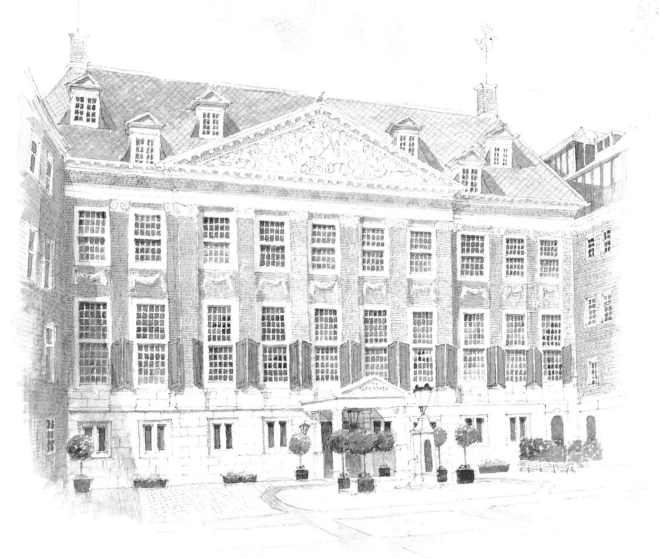

The Amstelkring Museum, also known as 'Our Beloved Lord in the Attic', is the only remaining house with a clandestine Catholic church in the attic. It dates from the time when Catholics were not allowed to profess their faith publicly.

The beautiful 'House on the Three Canals' stands with its front on Nieuwezijds Voorburgwal, its back on Oudezijds Achterburgwal and its side on Grimburgwal.

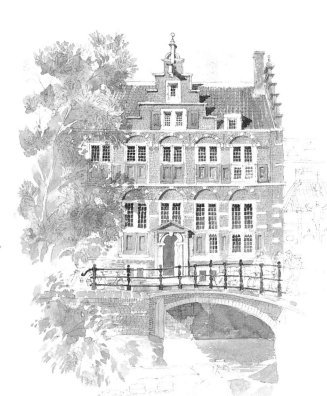

This is an early 17th-century house with a step gable and a small scullery outside where pots and pans were kept. Some of these sculleries were rented to tradesmen such as cobblers.

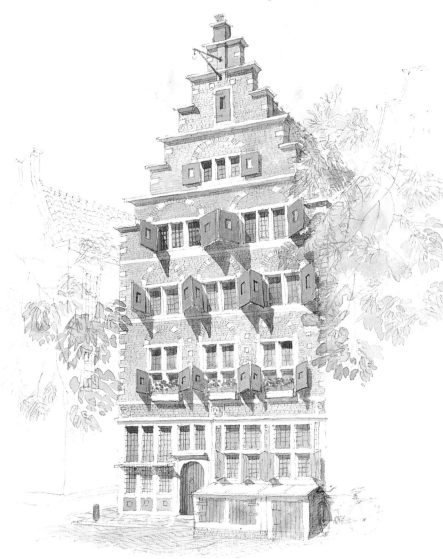

The Schreiersstoren (Weepers' Tower), it is said, got its name from the women who wept while saying goodbye to their sailor husbands. It would be a nice story, if it were true. Originally called the 'Schreihoekstoren' (Sharp-cornered Tower) it is the only surviving fortified tower.

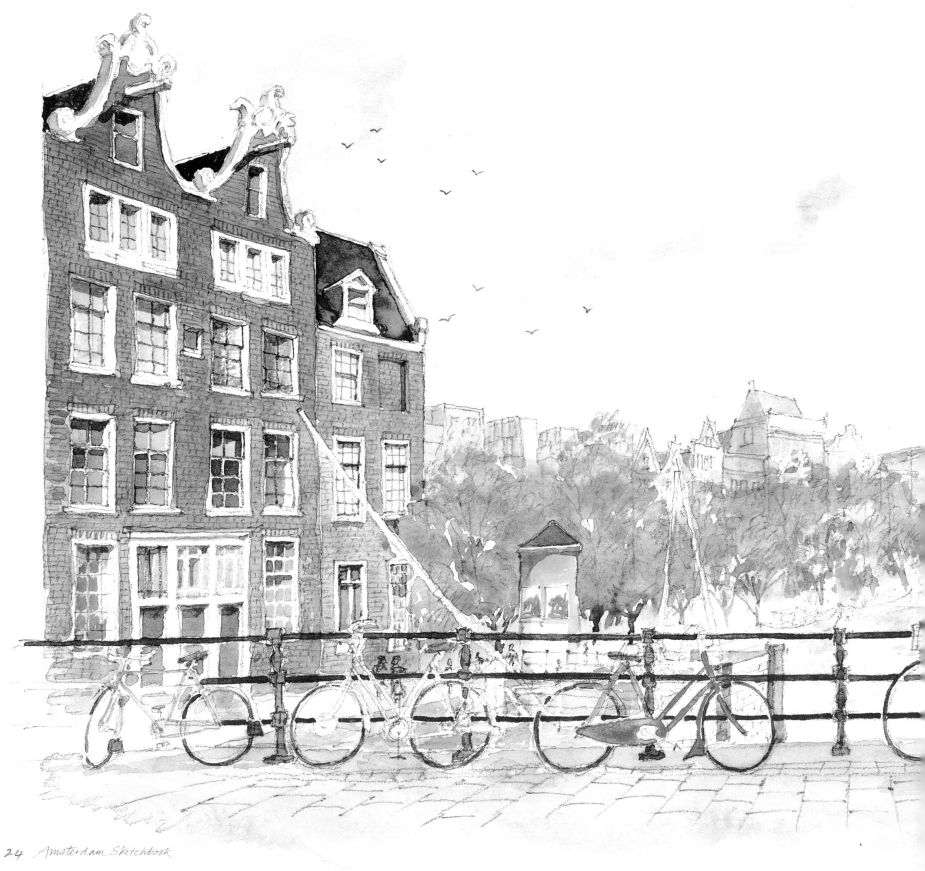

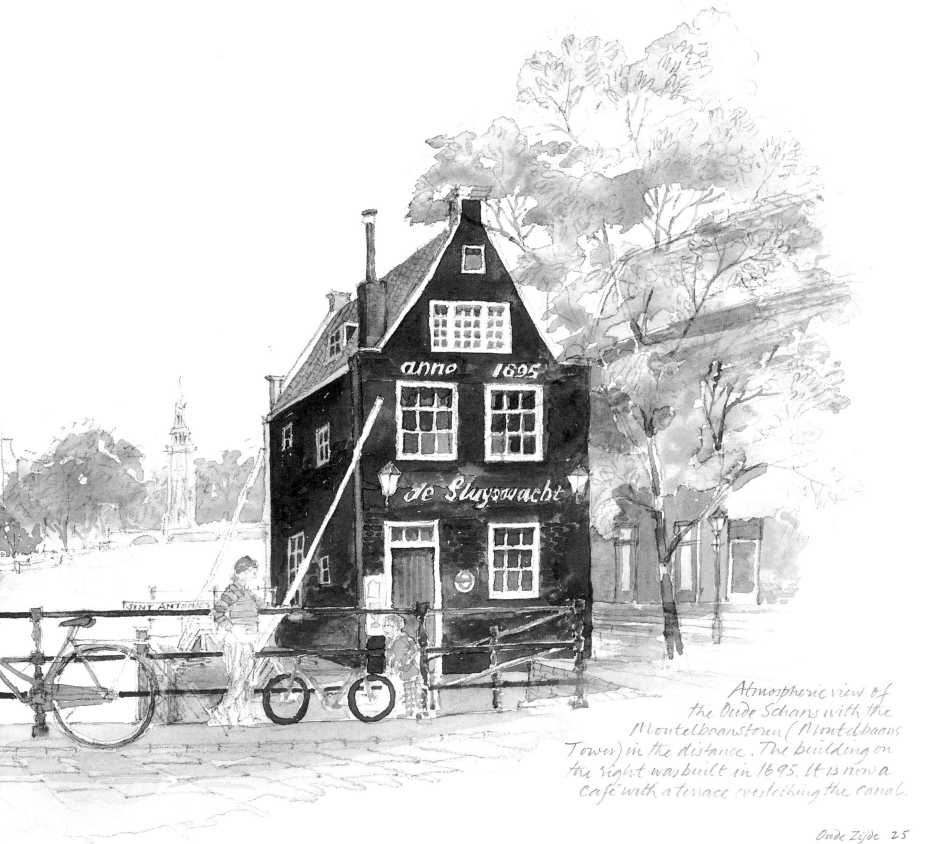

anno 1695

de Sluyswacht

SINT ANTONIES

Atmospheric view of
the Oude Schans with the
Montelbaanstoren (Montelbaans
Tower) in the distance. The building on
the right was built in 1695. It is now a
café with a terrace overlooking the canal.

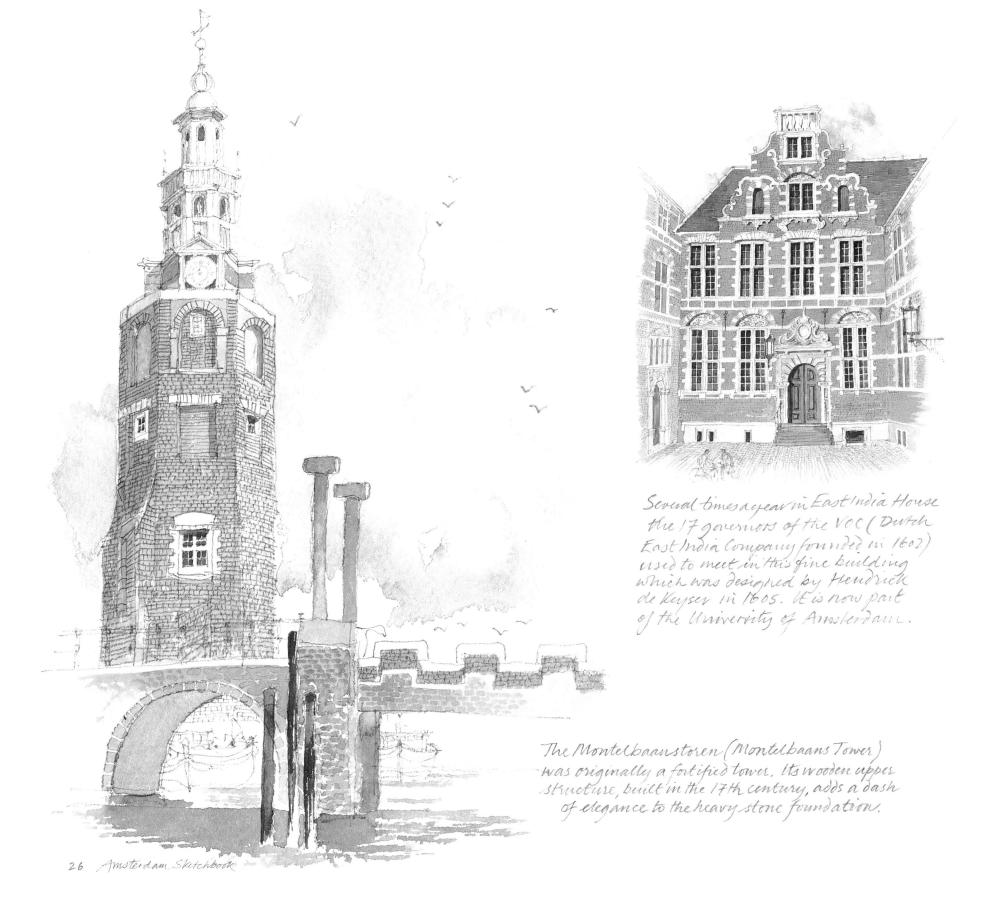

Several times a year in East India House
the 17 governors of the VOC (Dutch
East India Company founded in 1602)
used to meet in this fine building
which was designed by Hendrick
de Keyser in 1605. It is now part
of the University of Amsterdam.

The Montelbaanstoren (Montelbaans Tower)
was originally a fortified tower. Its wooden upper
structure, built in the 17th century, adds a dash
of elegance to the heavy stone foundation.

Amsterdam's Red Light District is an important tourist attraction. Sometimes it's difficult to get through the crowded narrow streets and quaysides with all the sex shops, night clubs, peep shows and, of course, the prostitutes in their windows.

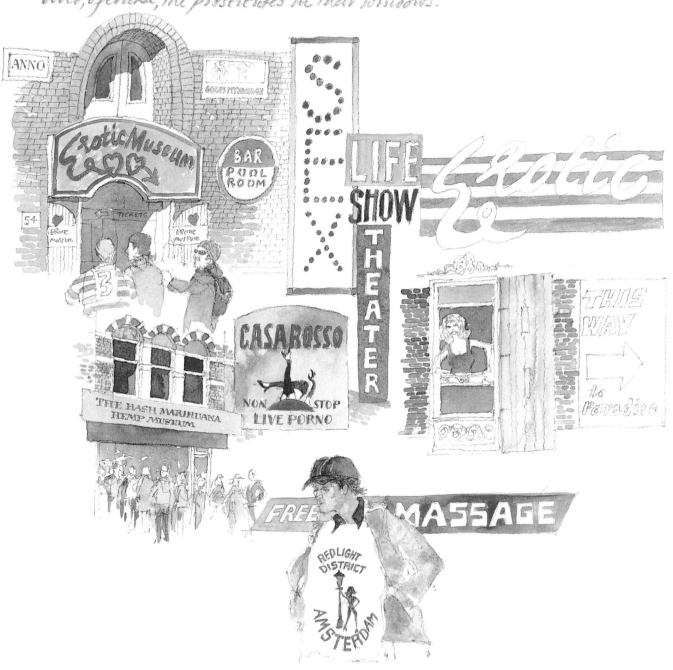

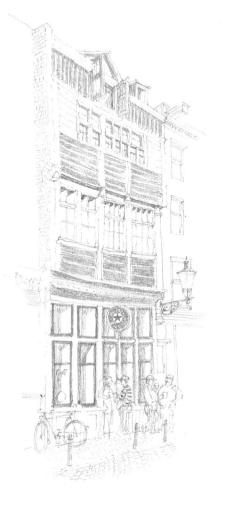

Café 't't Aepjen at No 1 Zeedijk, is one of the two surviving medieval wooden houses in Amsterdam. It is actually not made completely of wood as the side gables are stone.

The very large and beautiful Portuguese Synagogue is a Jewish 'cathedral'. The main building is accessed from the courtyard surrounded by the lower buildings which house a library about the history of the Spanish and Portuguese Jews.

Waterlooplein, with the Stopera complex comprising the Music Theatre and the Town Hall, displaced a flea market which had been here since the 19th century. The market now stretches out along the side and back of the Town Hall.

Zuiderkerk (Southern Church), with its soaring tower, was the first Protestant church in Amsterdam built after the Reformation. In the foreground is a house with a long-necked gable and another with a fine example of a bell gable.

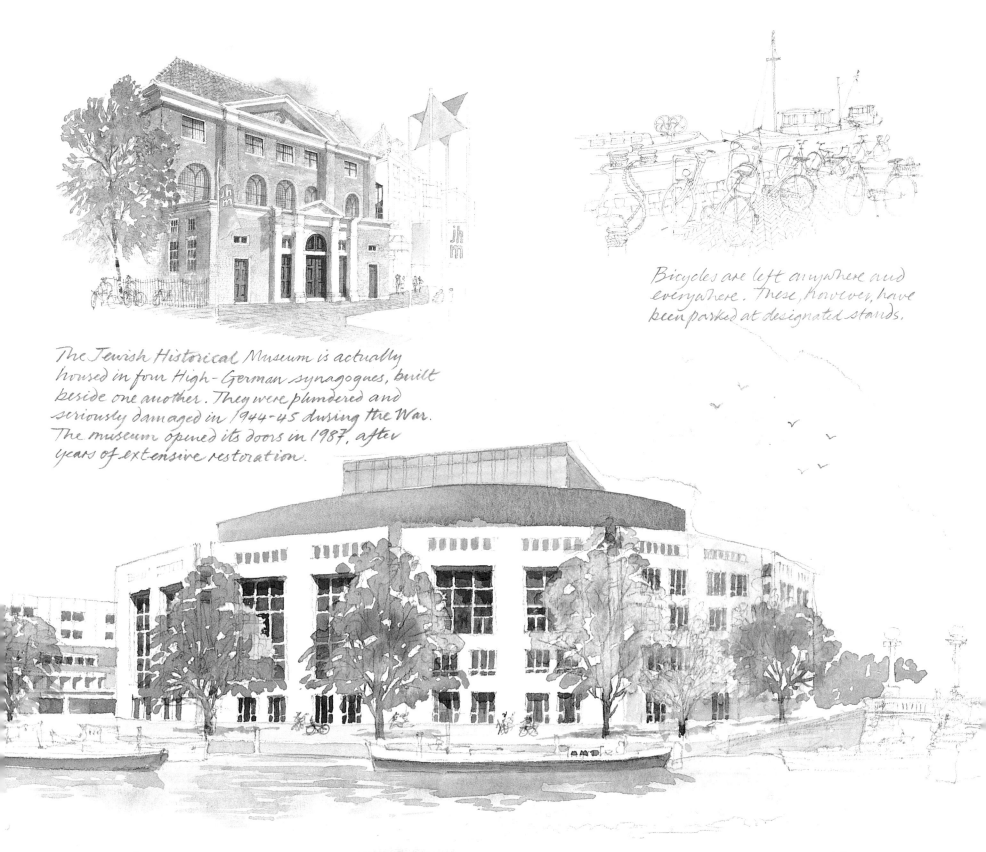

Bicycles are left anywhere and everywhere. These, however, have been parked at designated stands.

The Jewish Historical Museum is actually housed in four High-German synagogues, built beside one another. They were plundered and seriously damaged in 1944-45 during the War. The museum opened its doors in 1987, after years of extensive restoration.

Nieuwe Zijde

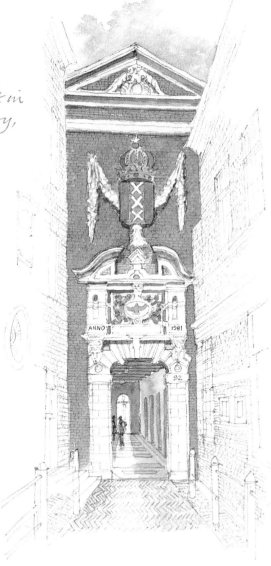

This entrance doorway, built in the 16th century, leads to the Amsterdam Historical Museum.

The centuries-old heart of the city is Dam Square. Here stands the 17th-century City Hall, later a Royal Palace, flanked by the much older Nieuwe Kerk (New Church) and opposite the 20th-century Nationaal Monument. The imposing City Hall building had many functions. It lodged not only burgomasters, the council of city fathers and the civil servants, but also the sheriff and his magistrates. Executions took place on a scaffold erected against the wall of the City Hall, watched by crowds that gathered on Dam Square. The Exchange Bank was also established in the Hall. Besides private investors, monarchs, cities and governments all had accounts here. Until well into the 18th century Amsterdam remained, thanks to the Exchange Bank, the most important financial centre in the world.

Dam Square is a place where people gather for all sorts of reasons—to party, protest, commemorate, riot, or just 'hang out'. Every year on 4 May, the victims of World War II are remembered here, with two minutes' silence. The square also plays a role during the inauguration of Dutch kings and queens, which takes place at Nieuwe Kerk: thereafter the monarch appears on the balcony of the palace to be sung to and cheered.

Almost lost on busy Kalverstraat is the entrance to the Amsterdam Historical Museum, located in the former city orphanage. The bas relief over the entrance reminds us of the orphans in their half-red, half-black uniforms. A visit to the museum is definitely worthwhile.

Next to the museum complex is the Begijnhof. It dates from 1346 and has expanded many times down the centuries. After the 'Alteration' of 1578, the Begijnen—an order of devoted Catholic lay sisters—were allowed to continue staying here. The houses here date from the 17th and 18th centuries. The Begijnhof is an oasis of quiet in the middle of a hectic shopping area.

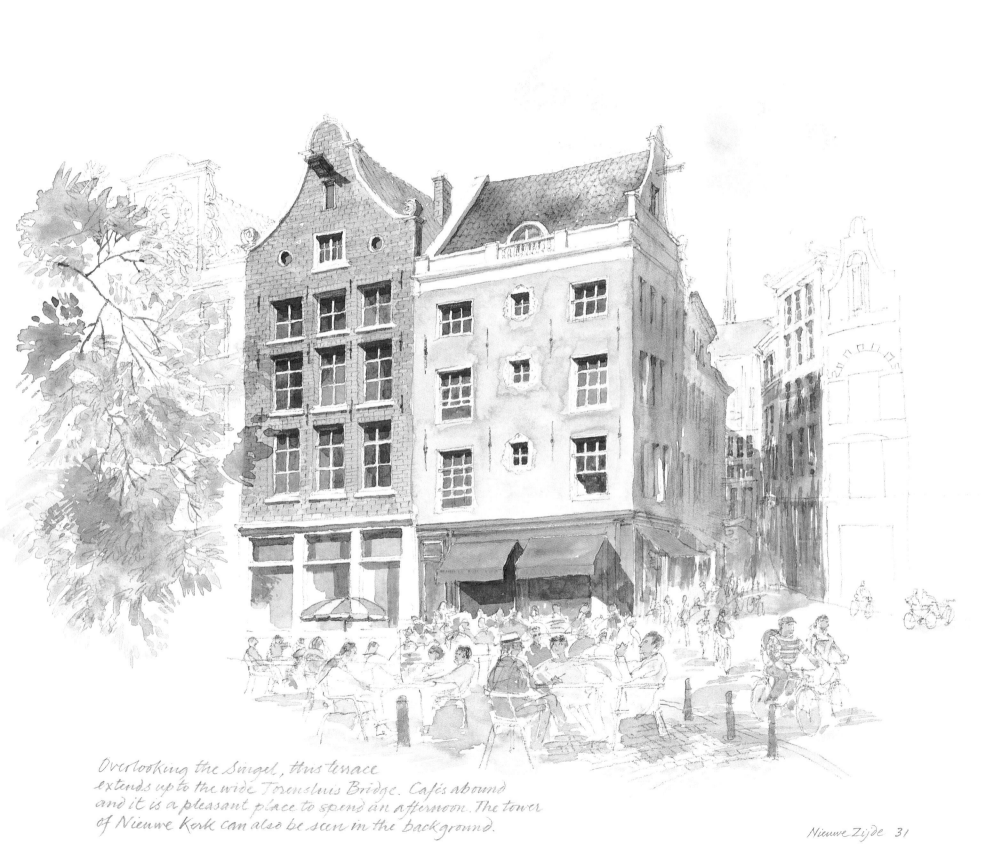

Overlooking the Singel, this terrace extends up to the wide Torensluis Bridge. Cafés abound and it is a pleasant place to spend an afternoon. The tower of Nieuwe Kerk can also be seen in the background.

Sint-Nicolaas Church actually stands on Oude Zijde, but it is best seen in all its glory from Nieuwe Zijde. Consecrated in 1888 it is a fine expression of the new found confidence amongst Catholics.

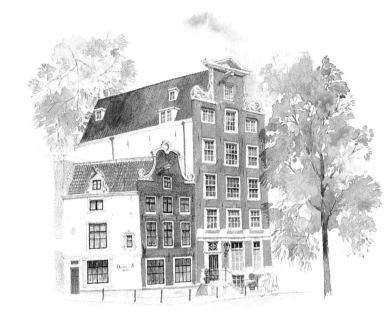

These two houses are on Nieuwezijds Voorburgwal. The shorter house was built in 1761 while the taller house was built in the 17th century. Restaurant Dorrius, since 1890, has served traditional Dutch food from these premises.

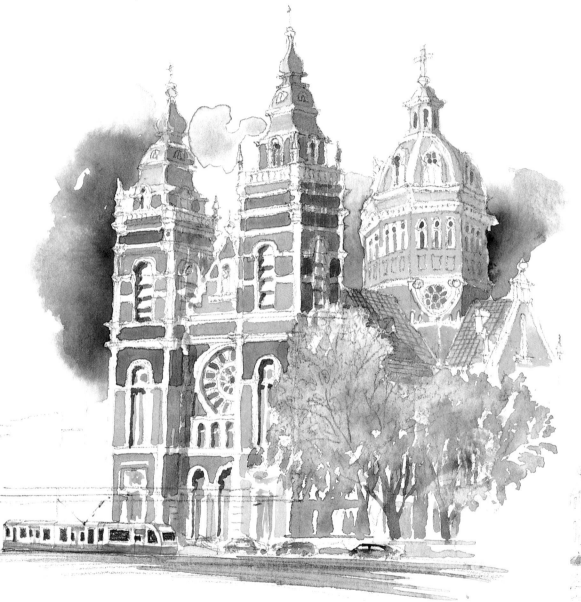

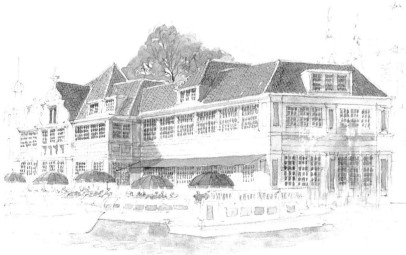

In front of Central Station is Noord-Zuid-Hollands Koffiehuis, a café-restaurant that dates from the early 20th century. Its charming white wood building is built partly over the water while its water-side terrace is a nice place to just linger.

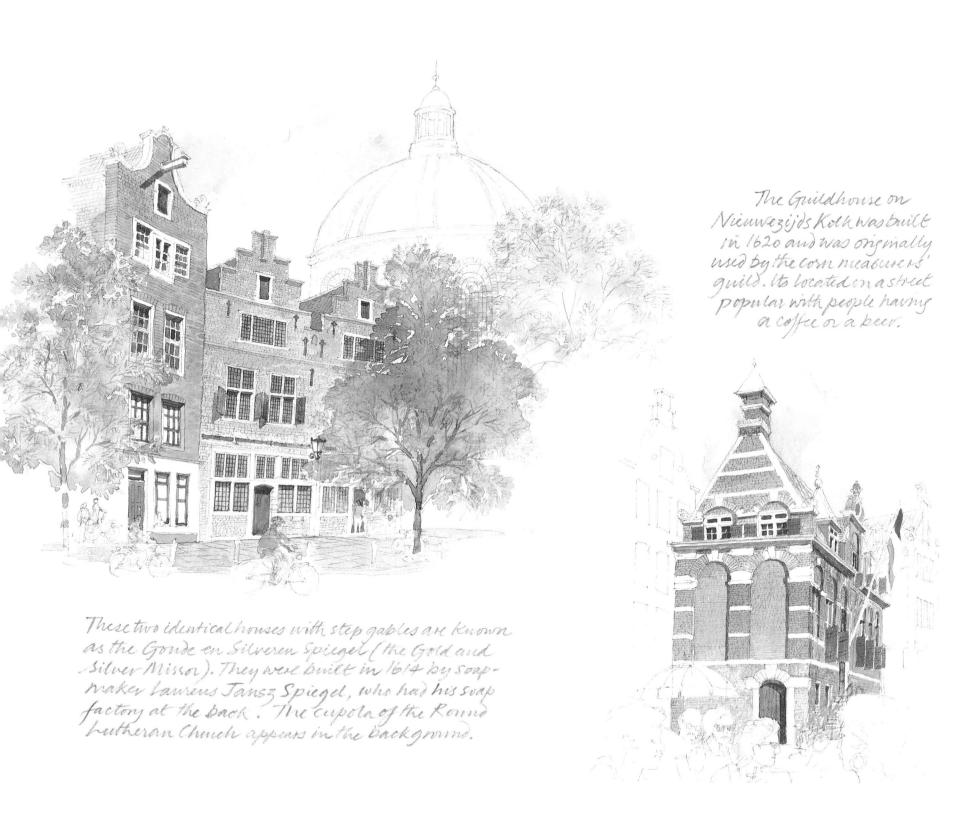

The Guildhouse on Nieuwezijds Kolk was built in 1620 and was originally used by the corn measurers' guild. Its located on a street popular with people having a coffee or a beer.

These two identical houses with step gables are known as the Gonde en Silveren Spiegel (the Gold and Silver Mirror). They were built in 1614 by soap-maker Laurens Jansz Spiegel, who had his soap factory at the back. The cupola of the Round Lutheran Church appears in the background.

Built in the 17th century originally as the City Hall, the Royal Palace on the Dam is one of the palaces of Queen Beatrix of the Netherlands. The Palace is used, among other functions, during state visits and for other official events. When the Queen is not in residence, some parts of the building with its impressive interiors, are open to the public. The main palaces of Queen Beatrix are in the Hague.

The medieval Nieuwe Kerk (New Church) is a handsome, cross-shaped basilica with a tower above its transept. The church is now used as an exhibition space, but is itself worth visiting. There are many works of art to admire including a 16th century organ and another large beautifully decorated organ built in the 17th century with which concerts are performed.

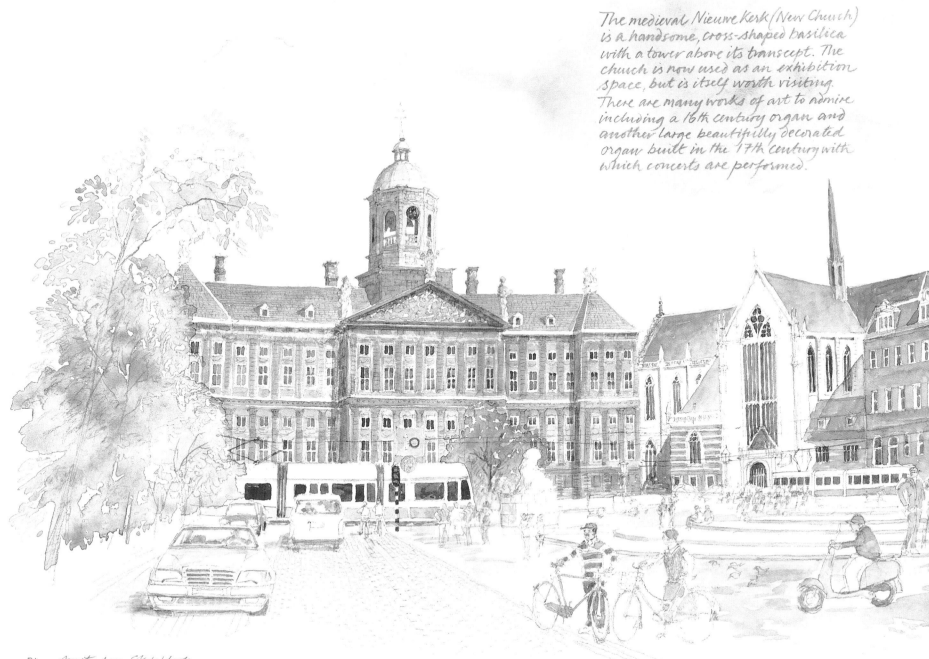

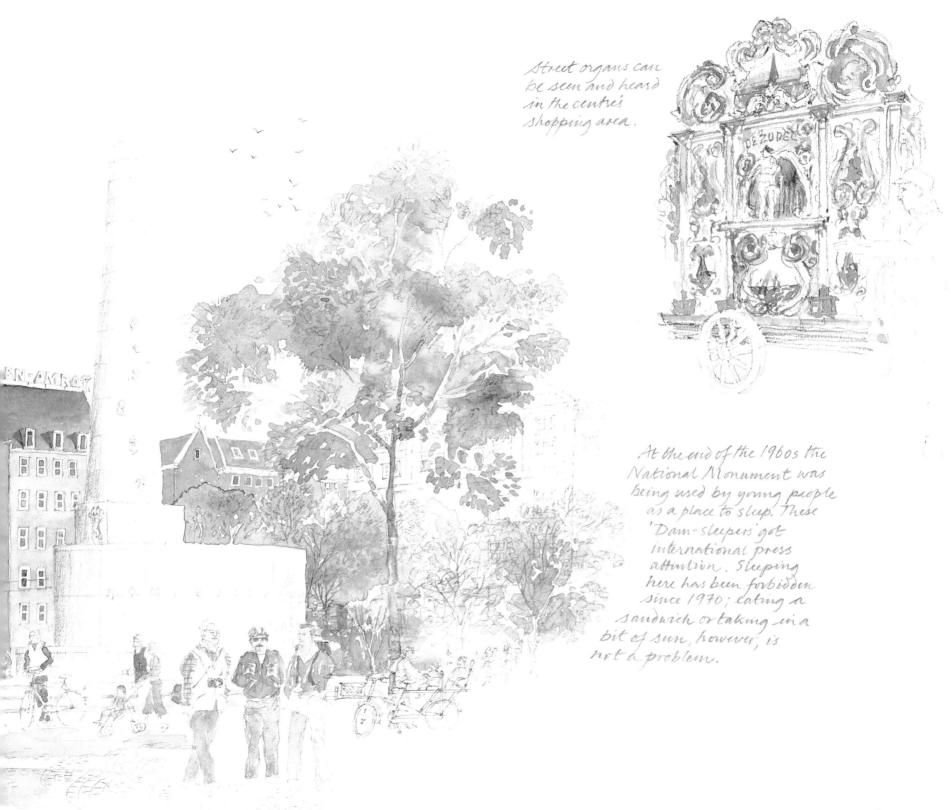

Street organs can
be seen and heard
in the centre's
shopping area.

At the end of the 1960s the
National Monument was
being used by young people
as a place to sleep. These
'Dam-sleepers' got
international press
attention. Sleeping
here has been forbidden
since 1970; eating a
sandwich or taking in a
bit of sun, however, is
not a problem.

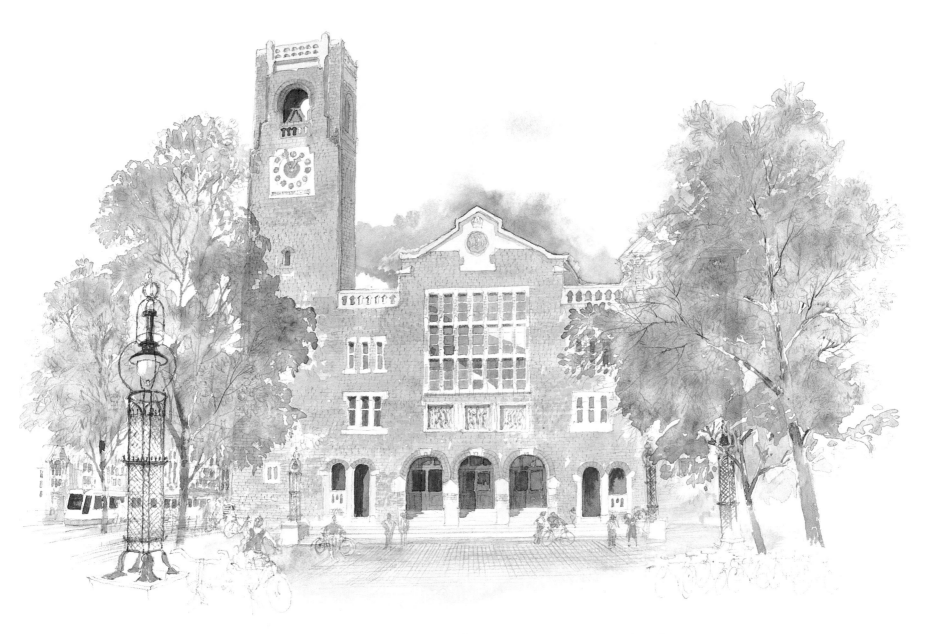

The design of the Stock Exchange by H.P. Berlage was in its day, shockingly new, and not everyone liked it. 'A large box with a cigarette box on top', was how one critic described it. But the 'big box' has had a huge influence on modern architecture in the Netherlands and the rest of the world. The lantern on the left was also designed by Berlage and has also become a monument.

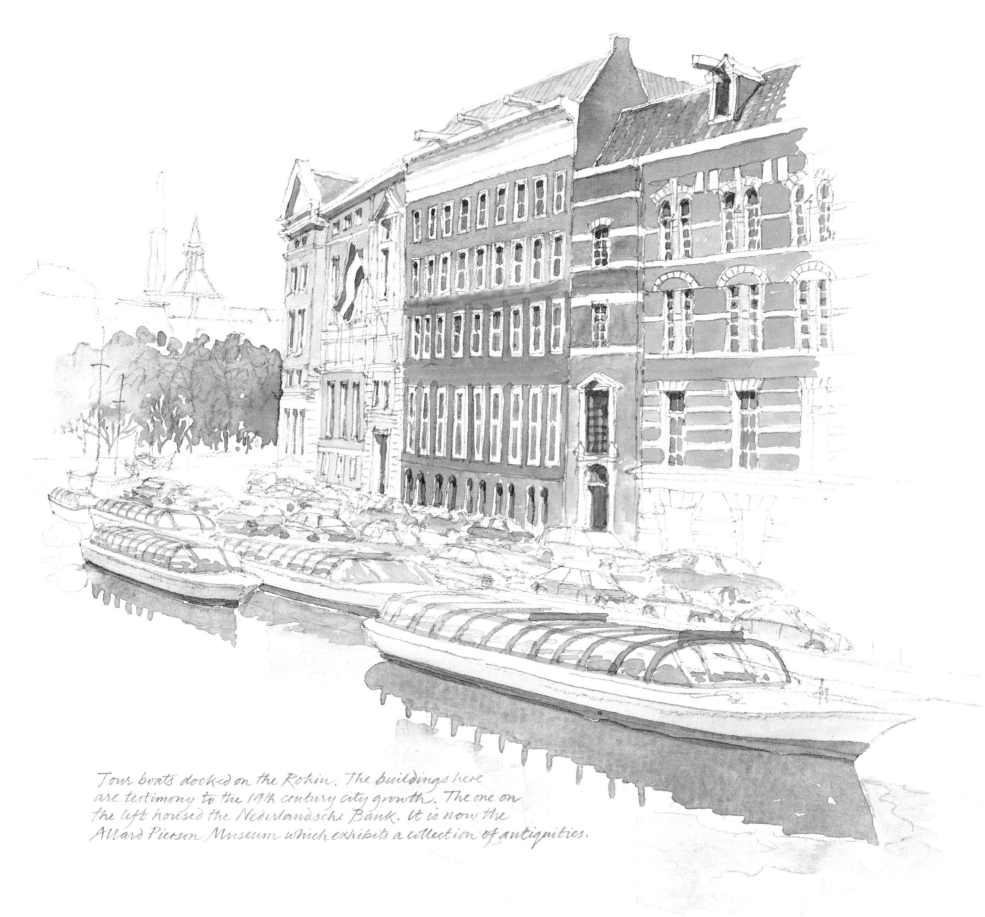

Tour boats docked on the Rokin. The buildings here
are testimony to the 19th century city growth. The one on
the left housed the Nederlandsche Bank. It is now the
Allard Pierson Museum which exhibits a collection of antiquities.

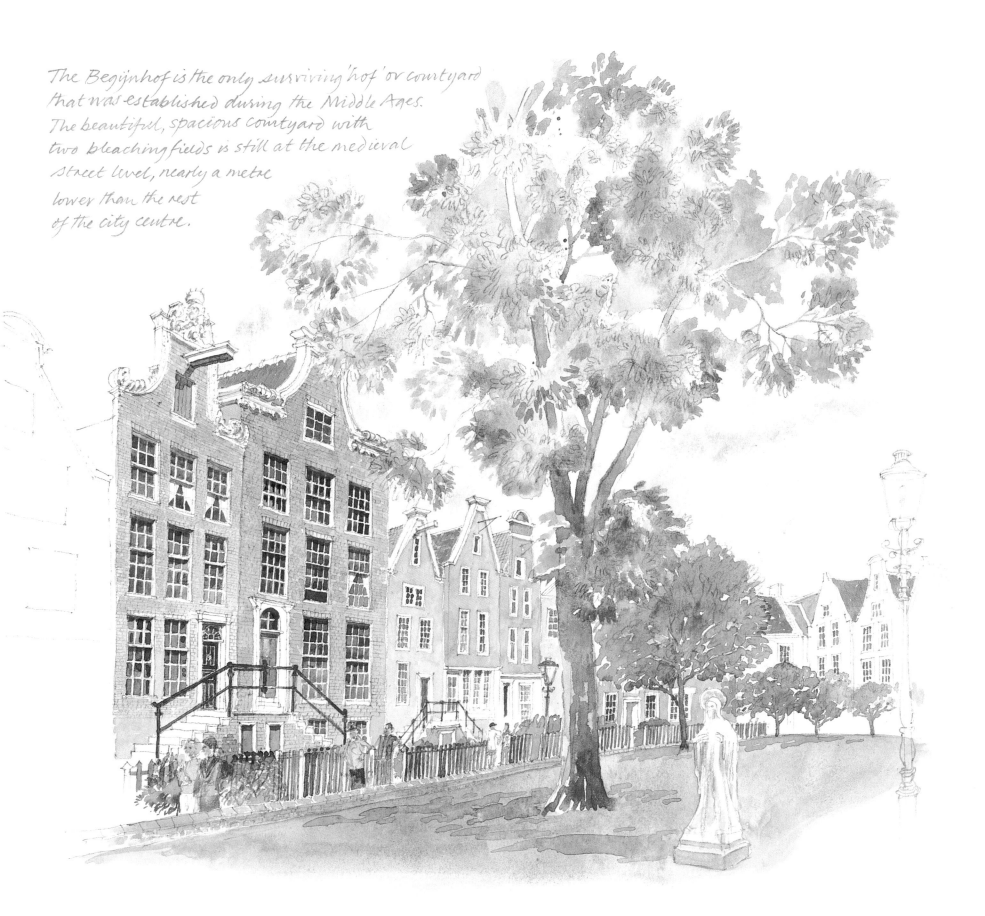

The Begijnhof is the only surviving 'hof' or courtyard
that was established during the Middle Ages.
The beautiful, spacious courtyard with
two bleaching fields is still at the medieval
street level, nearly a metre
lower than the rest
of the city centre.

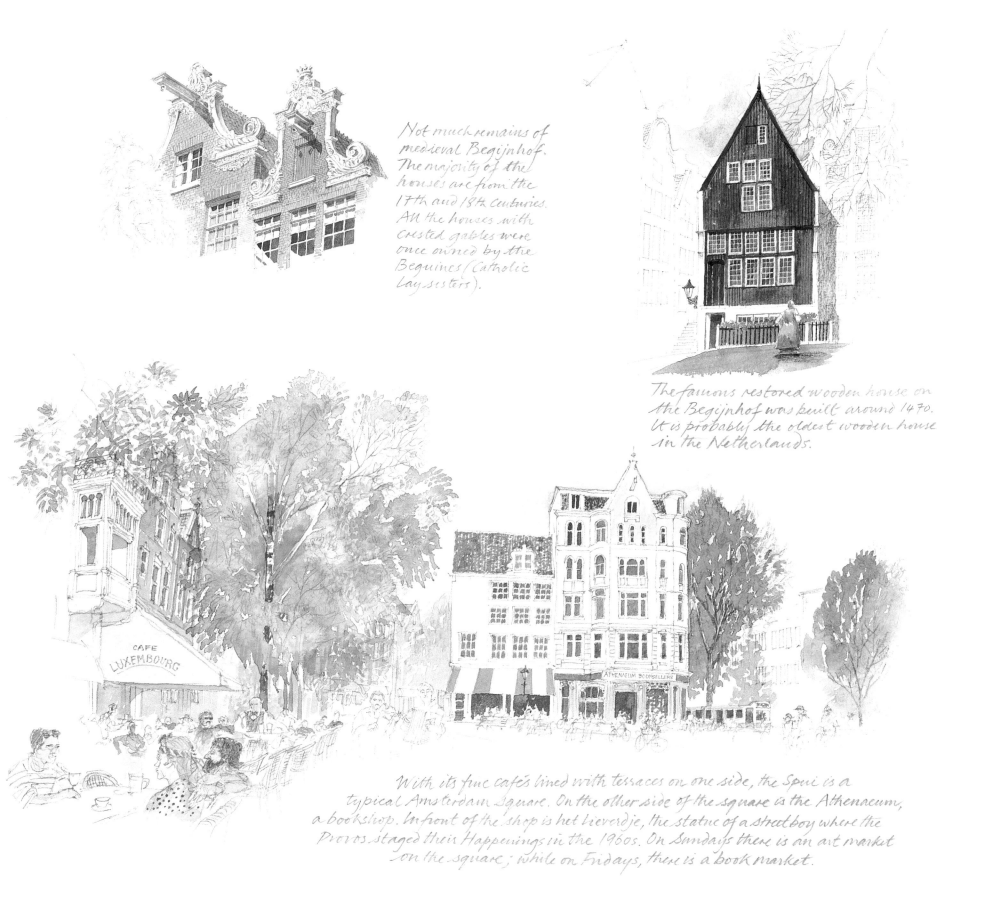

Not much remains of medieval Begijnhof. The majority of the houses are from the 17th and 18th Centuries. All the houses with crested gables were once owned by the Beguines (Catholic Lay sisters).

The famous restored wooden house on the Begijnhof was built around 1470. It is probably the oldest wooden house in the Netherlands.

CAFE LUXEMBOURG

ATHENAEUM BOOKSELLERS

With its fine cafés lined with terraces on one side, the Spui is a typical Amsterdam Square. On the other side of the square is the Athenaeum, a bookshop. In front of the shop is het Lieverdje, the statue of a streetboy where the Provos staged their Happenings in the 1960s. On Sundays there is an art market on the square; while on Fridays, there is a book market.

From Brouwersgracht to Rozengracht

The western section of the canal ring was the first to be laid out, in 1613. Developments, unlike today, were not handed over completely ready. The city prepared the ground for building and then distributed equal parcels of land, at least on the main canals. Whoever wanted a larger house had to buy more parcels of land. Construction was left to the individual. In Amsterdam, even today, all houses are on pile foundations; otherwise they sink into the weak soil.

Many people wanted their houses to be designed by the best master builders of the time. Some of the houses are veritable palaces, reserved for the rich. Most are one-parcel wide, but the houses built on the parcels vary greatly. Owners could decide on what they wanted, design-wise, according to the fashion of the day. Apart from the material, people also differed in the choice of decoration, notably in the type of gable. There were many types to choose from: step gables, spout gables, bell gables, and neck gables, an elongated version of the neck gable; double dwellings frequently got a cornice, a horizontal band at the top of the façade, usually richly decorated. The 'House with the Heads' on Keizersgracht is a beautiful example of a city palace.

The Jordaan was laid out at right angles to the canal belt, and was intended as a housing area for petit bourgeois and craftsmen. Use was made of the existing pattern of ditches and pathways, which is why the neighbourhood lies at such a sharp angle to the canal ring. Narrow streets are crossed by a number of canals, where the better-off lived. During the 19th century the Jordaan became an area for the poor, and it remained so well into the 20th. The Jordaan has been somewhat romanticised because of its past, but the old Jordaan does not exist anymore. The slums have been demolished. It now has shopping streets and a good number of pubs and restaurants.

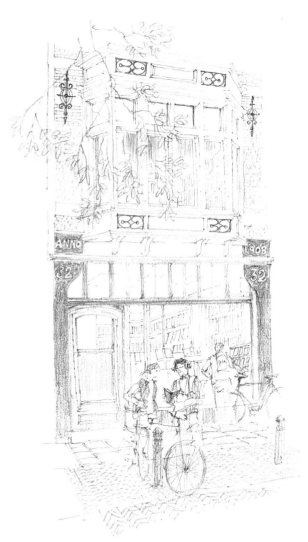

Amsterdam has a large number of small bookshops, many of them dedicated to specialised subjects.

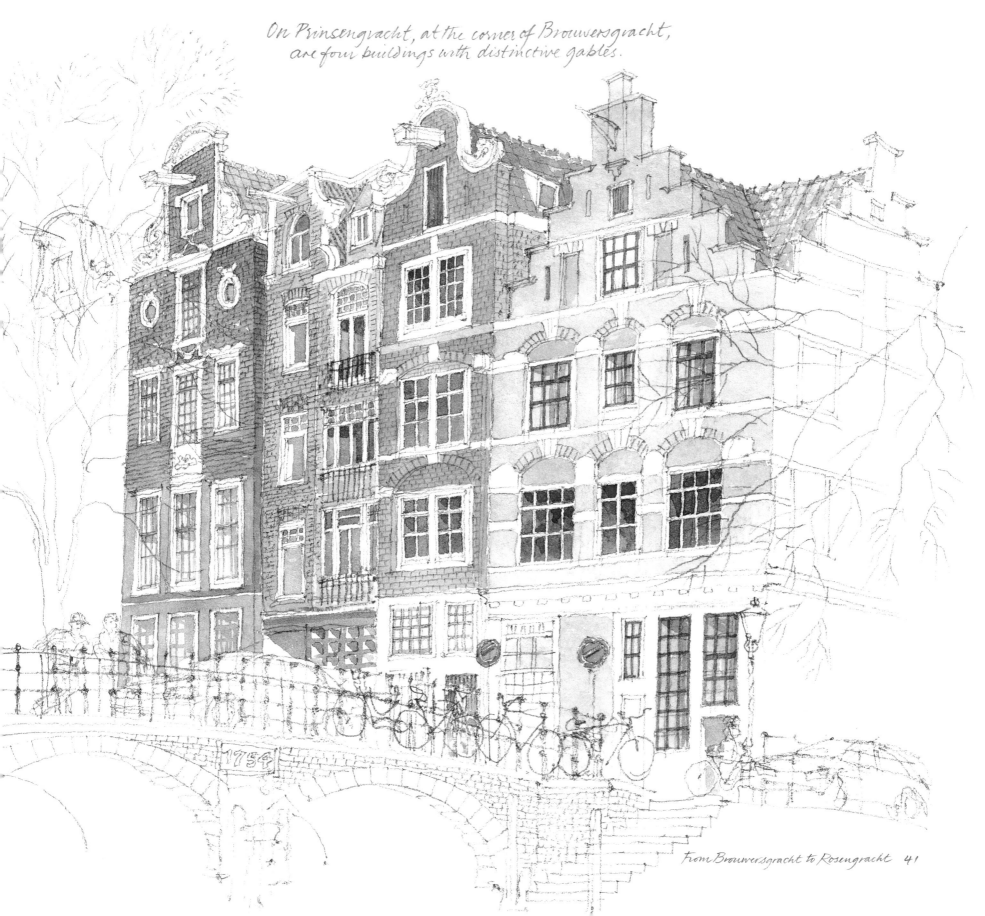

On Prinsengracht, at the corner of Brouwersgracht,
are four buildings with distinctive gables.

1754

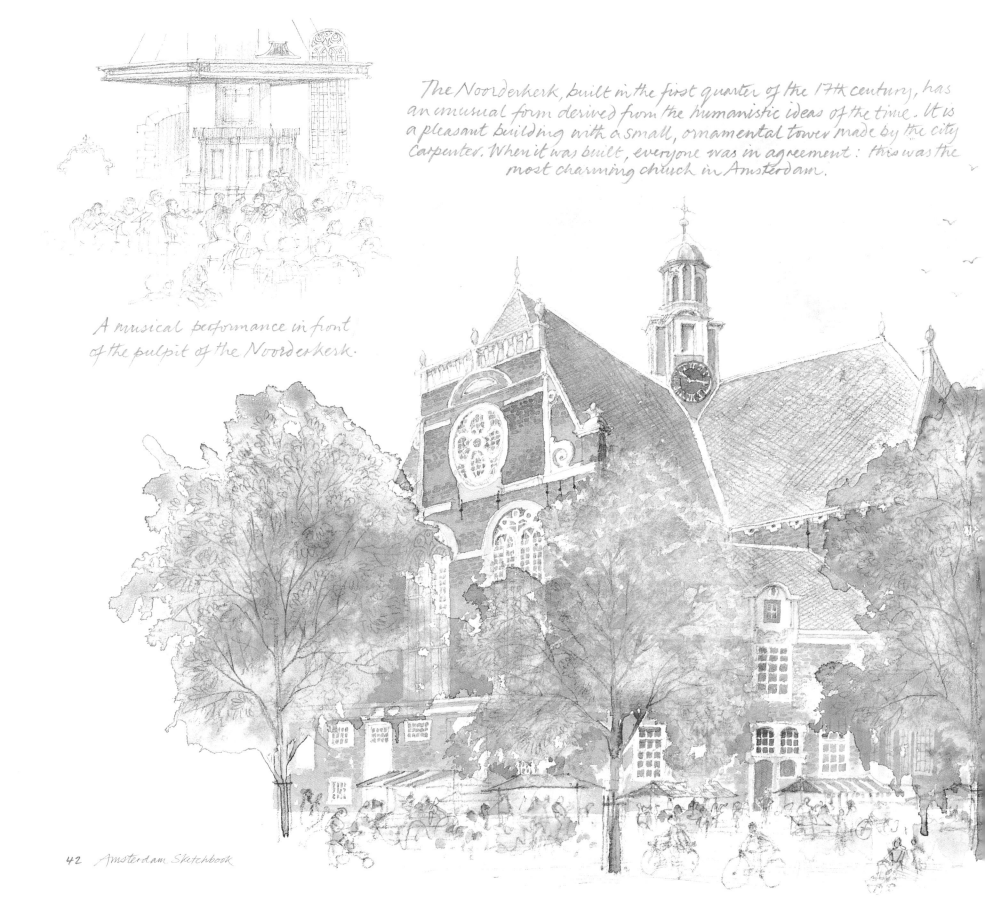

The Noorderkerk, built in the first quarter of the 17th century, has an unusual form derived from the humanistic ideas of the time. It is a pleasant building with a small, ornamental tower made by the city carpenter. When it was built, everyone was in agreement: this was the most charming church in Amsterdam.

A musical performance in front of the pulpit of the Noorderkerk.

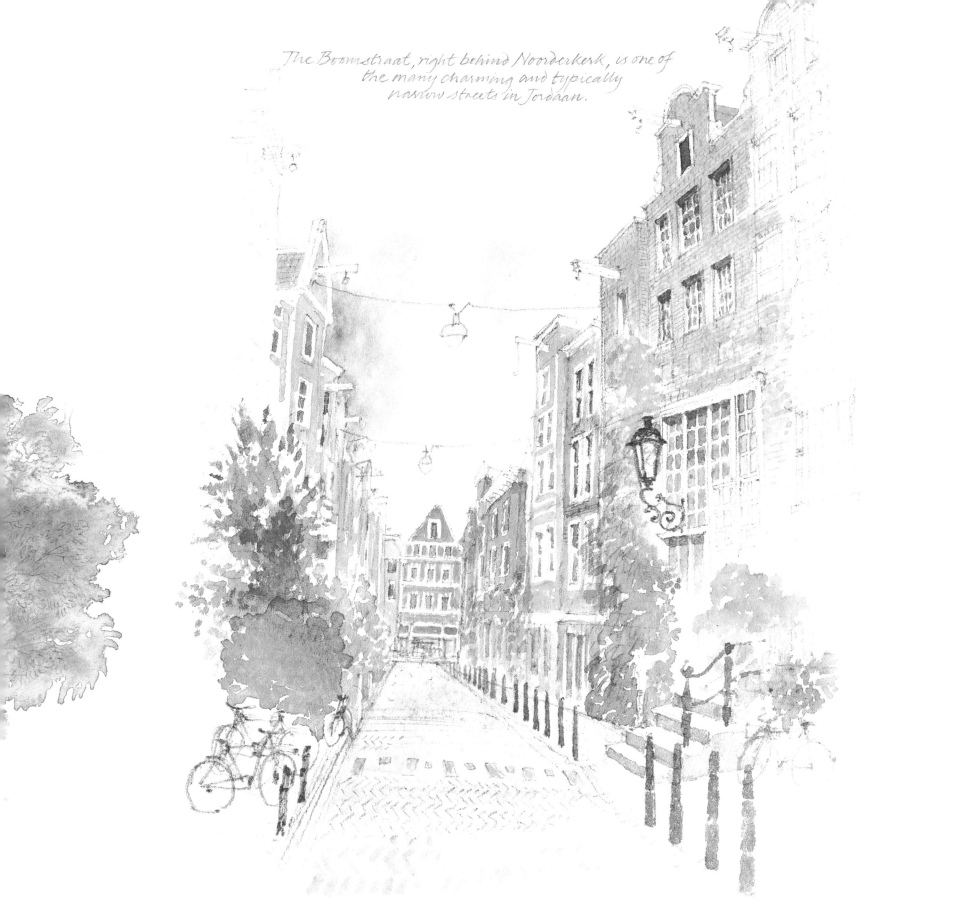

The Boomstraat, right behind Noorderkerk, is one of
the many charming and typically
narrow streets in Jordaan.

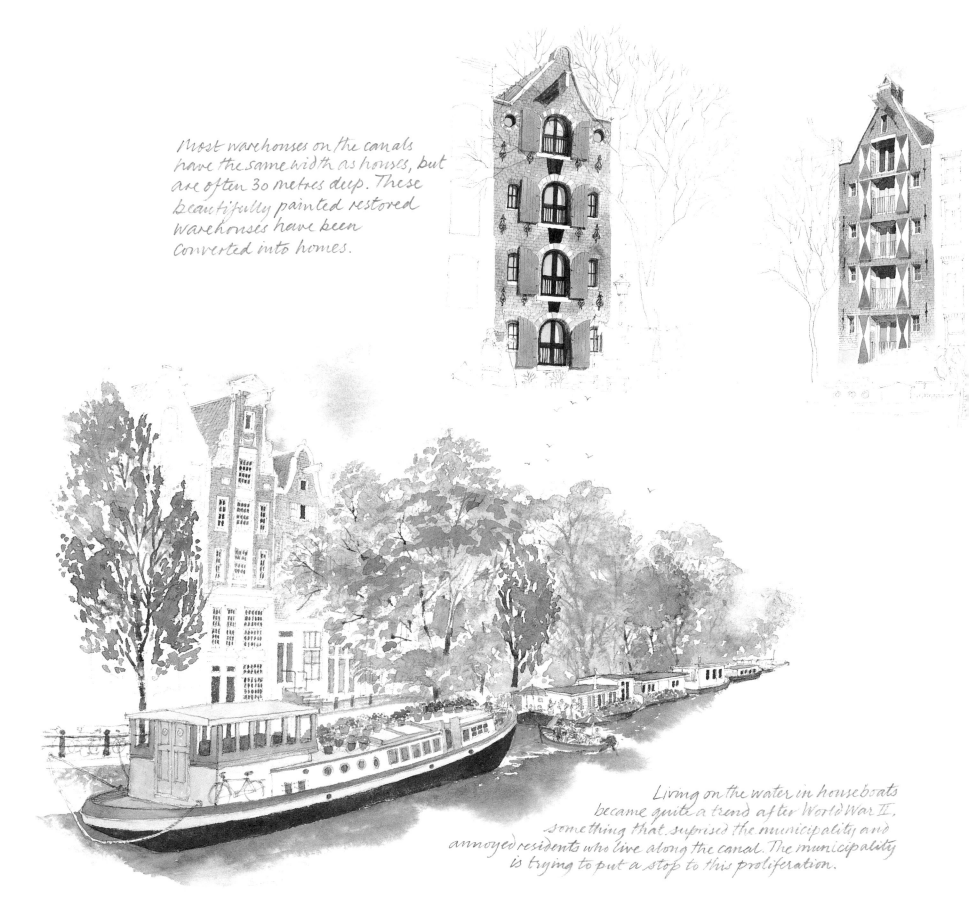

Most warehouses on the canals have the same width as houses, but are often 30 metres deep. These beautifully painted restored warehouses have been converted into homes.

Living on the water in houseboats became quite a trend after World War II, something that suprised the municipality and annoyed residents who live along the canal. The municipality is trying to put a stop to this proliferation.

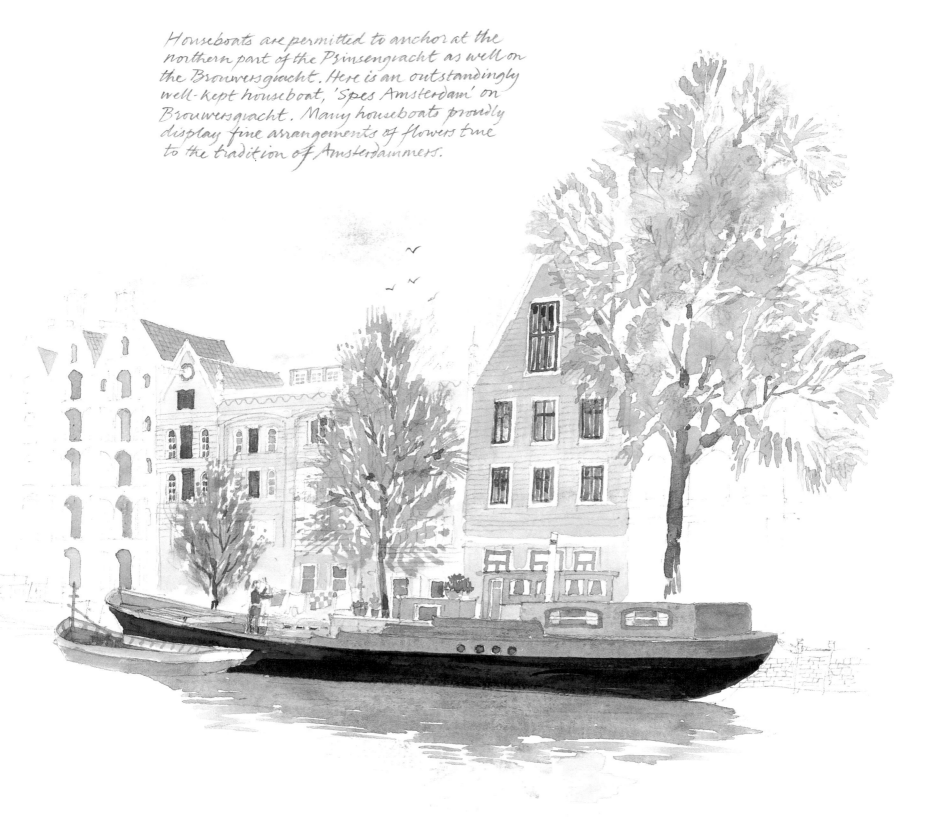

Houseboats are permitted to anchor at the
northern part of the Prinsengracht as well on
the Brouwersgracht. Here is an outstandingly
well-kept houseboat, 'Spes Amsterdam' on
Brouwersgracht. Many houseboats proudly
display fine arrangements of flowers true
to the tradition of Amsterdammers.

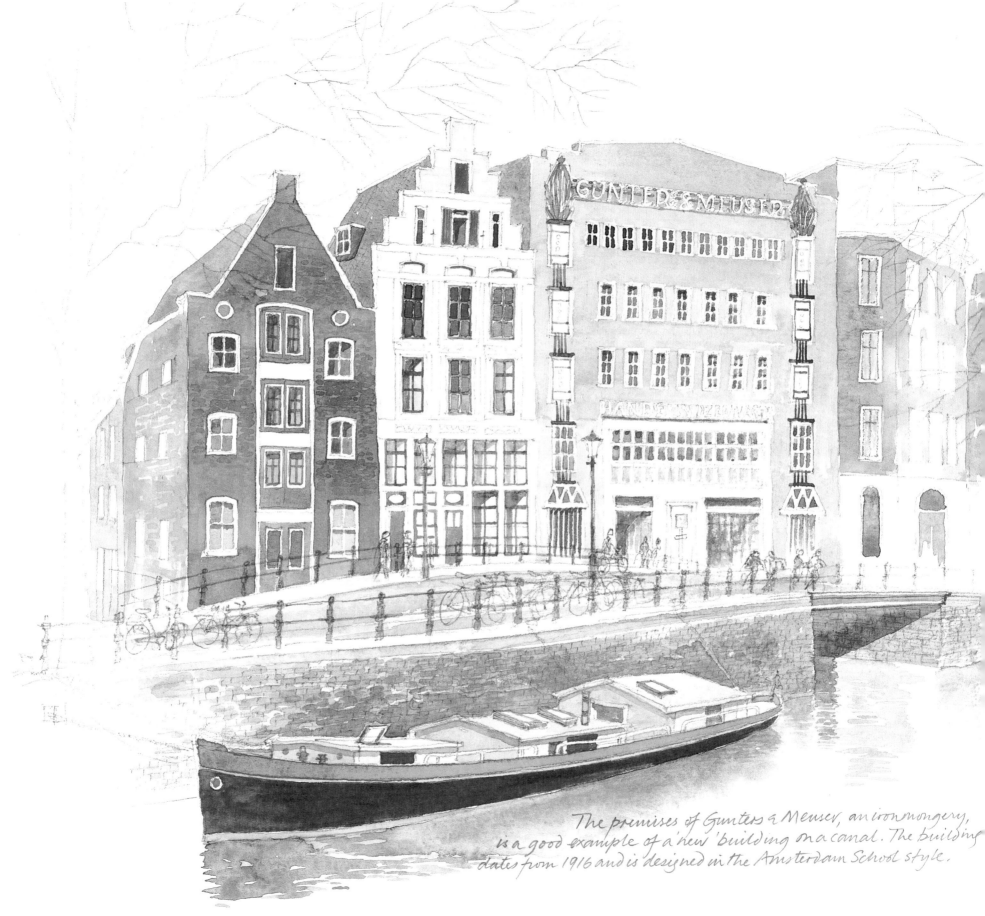

The premises of Gunters & Meuser, an ironmongery, is a good example of a 'new' building on a canal. The building dates from 1916 and is designed in the Amsterdam School style.

Gable stones are small, colourful carved artworks found everywhere in Amsterdam. It was a way of identifying a house in the days before house numbers. The sculptor of this modern example had a sense of humour: the year '1972' is upside-down and the place name 'Lindengracht' is carved backwards.

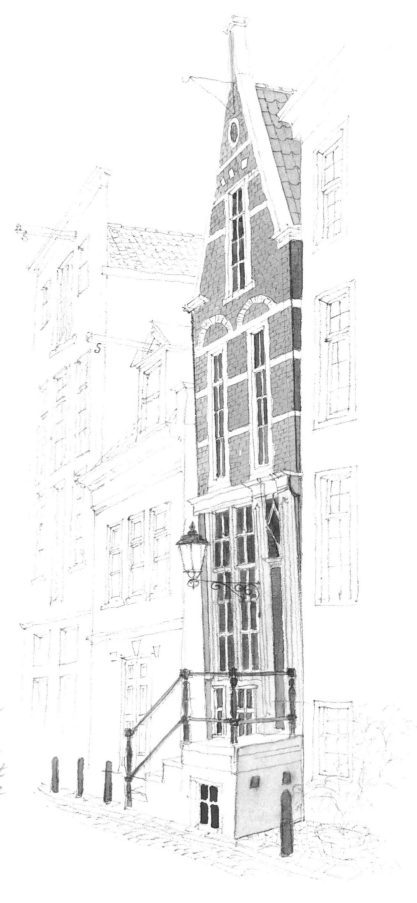

Some 17th-century houses, such as this one, lean outwards. This style dates from the Middle Ages. The wooden houses that were built like this often had an upper façade that leaned forward to protect the lower parts of the façade – with its expensive leaded glass windows – from the elements.

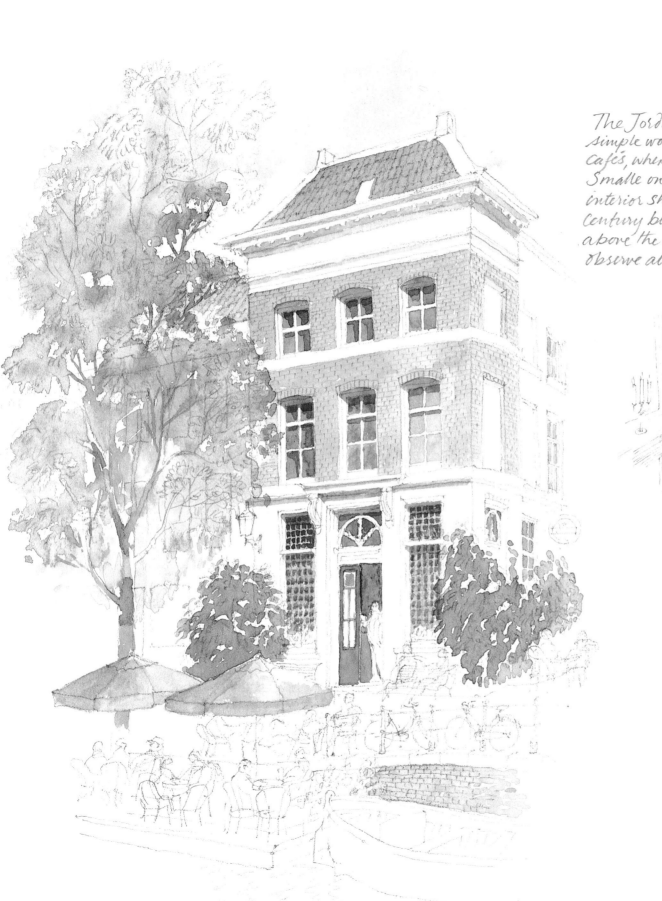

The Jordaan has many cosy old pubs with simple wooden furniture known as 'brown' cafés, where people stay for hours. Café 't Smalle on the Egelantiersgracht with its interior shown below, is housed in an 18th century building. Its terrace is constructed above the canal, allowing patrons to observe all the activities on the water.

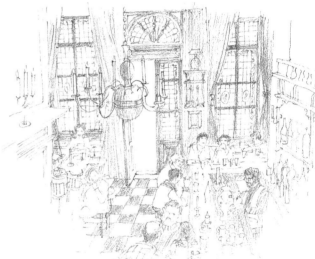

This wide canal house with a beautiful Renaissance gable is known as the 'House with the Heads' because the facade is ornamented with heads of six classical gods. Built in 1622, the house was bought in 1634 by the merchant Louis de Geer, who made his considerable fortune in, amongst other things, armaments.

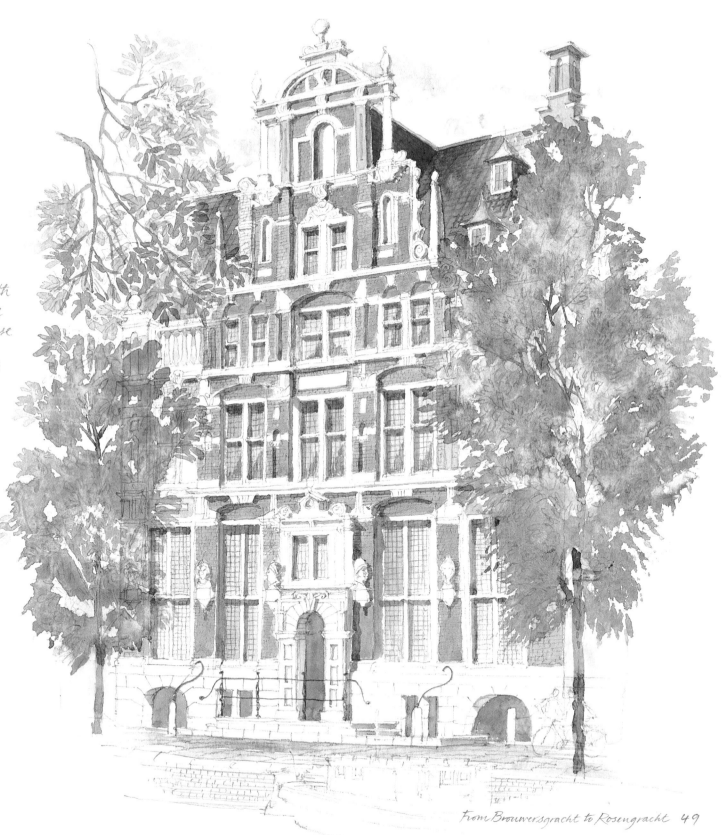

A view of the much-loved Westertoren (Western Tower) from a bridge over the Prinsengracht. Amsterdam received the privilege of including the imperial crown in its coat of arms from Maximilian I of Austria in 1489. Ever since it was built in the 17th century, Westertoren has born the imperial crown.

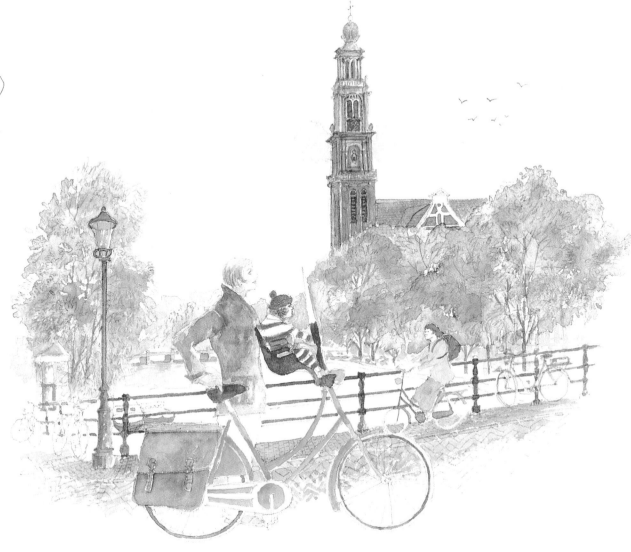

A familiar sight in Amsterdam: a subsiding house that needs propping up with wooden beams.

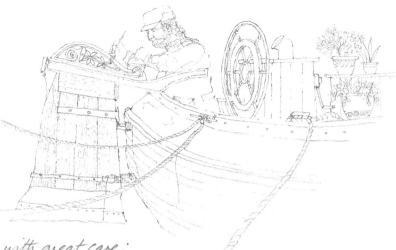

Boats are decorated with great care: with potted plants and other trimmings.

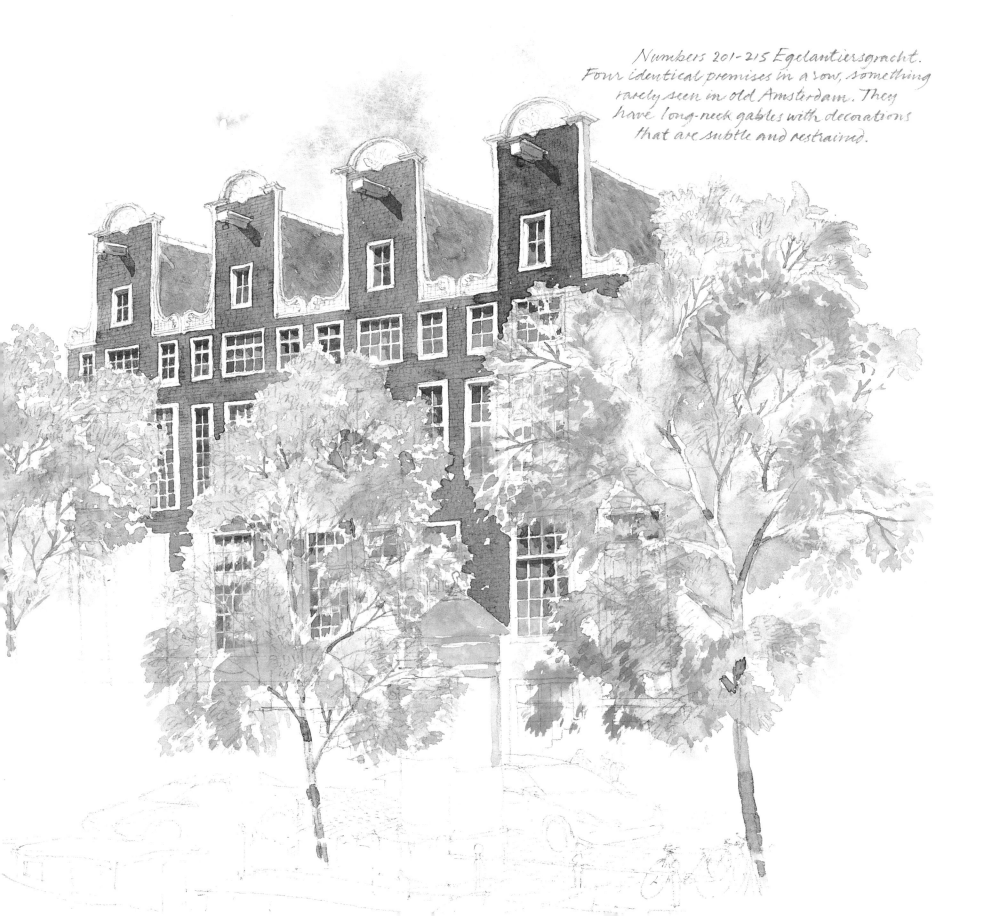

Numbers 201-215 Egelantiersgracht.
Four identical premises in a row, something
rarely seen in old Amsterdam. They
have long-neck gables with decorations
that are subtle and restrained.

Around Leidsestraat

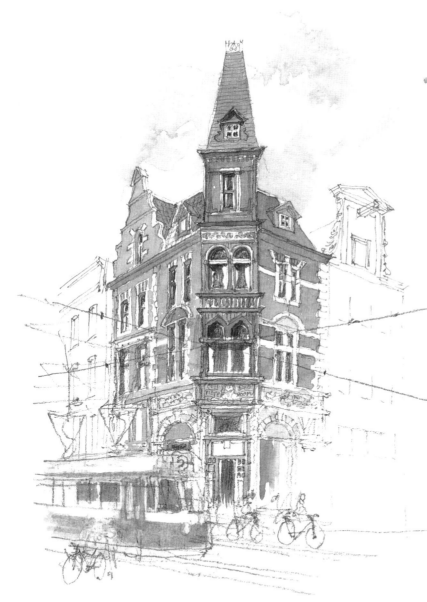

An 1881 corner building on Leidsestraat, with towers and bay windows.

I n Amsterdam a canal address has always been prestigious—even more so within the canal ring. The richest lived on the Herengracht. Fabulous houses were built between Leidsestraat and Vijzelstraat, the 'Golden Bend', which was almost as upper-class as the Keizersgracht. A few companies established themselves on the Prinsengracht, something not permitted on the other canals. 'Ordinary' people lived in the narrow streets which connect the canals at regular intervals, while others lived as household staff in the more stately premises.

Water transport was important. Goods were transferred onto small boats in the harbour, which took them into the city. During winter, people enjoyed themselves on the ice, especially in the 17th century when a mini-Ice Age occurred. In recent times, the canals have not frozen over for years.

The only street that cuts through this part of the canal belt is Leidsestraat, which was neglected for much of the 19th century. At the end of the century it underwent a facelift and the shopping area extended here from Kalverstraat via the Heilige Weg. Façades were widened, and large shop windows appeared, each shop interior more beautiful than the next. The corners where the streets met the canals were perfect for new buildings. Here architects were permitted to build higher than on the street itself, often incorporating towers and bay windows into their designs.

Leidsestraat opens out onto Leidseplein. This was the southernmost point of the city in the 17th century. The Stadsschouwburg (City Theatre) has stood here since 1774. In 1880 it was joined by the American Hotel. Opposite was the fashionable department store Hirsch & Cie. Initially it occupied a pre-existing building, and then the owners built what was, for Amsterdam, a gigantic palace of fashion. Meanwhile, the Stadsschouwburg was destroyed by fire in 1890. Four years later a new theatre was built in red brick, and is now one of the most beautiful surviving theatres.

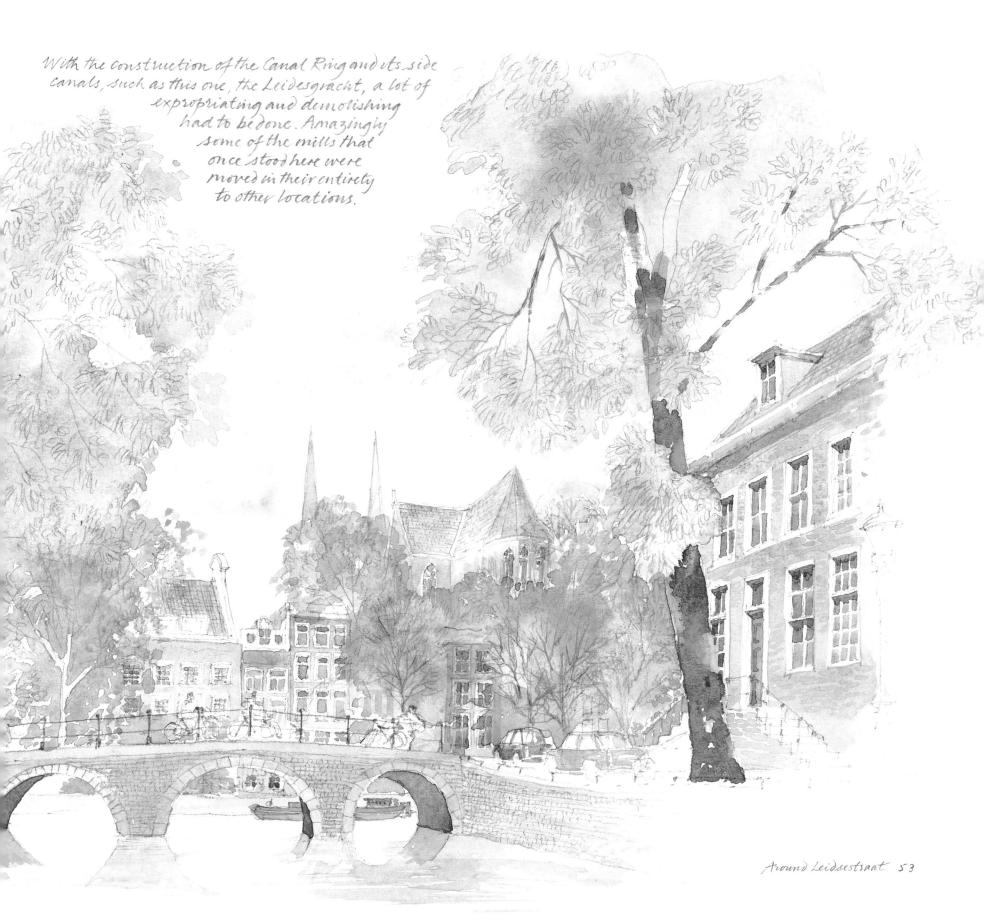

With the construction of the Canal Ring and its side canals, such as this one, the Leidesgracht, a lot of expropriating and demolishing had to be done. Amazingly some of the mills that once stood here were moved in their entirety to other locations.

Around Leidsestraat 53

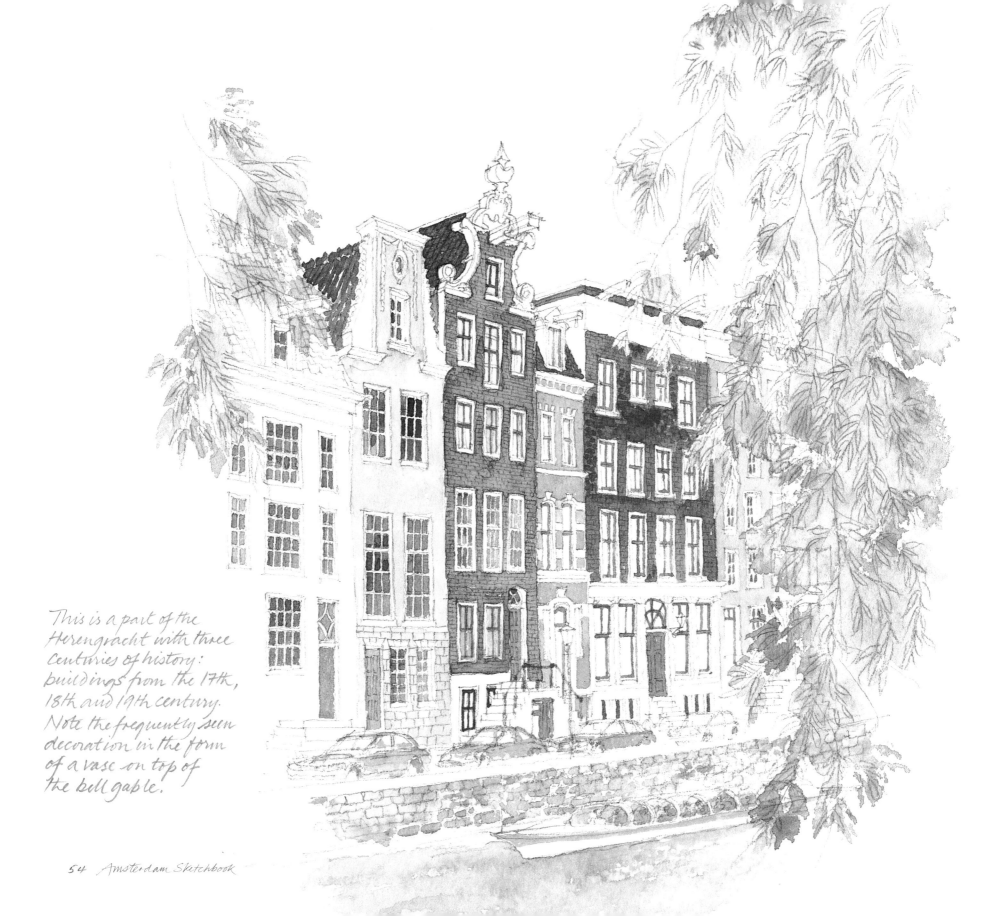

This is a part of the
Herengracht with three
centuries of history:
buildings from the 17th,
18th and 19th century.
Note the frequently seen
decoration in the form
of a vase on top of
the bell gable.

The Felix Meritis building, designed in Louis-XVI style, is regarded as the city's most beautiful monument from the 18th century. An arts and science society, the Felix Meritis was a progressive institution ahead of its time, and was for many years the centre of Amsterdam culture.

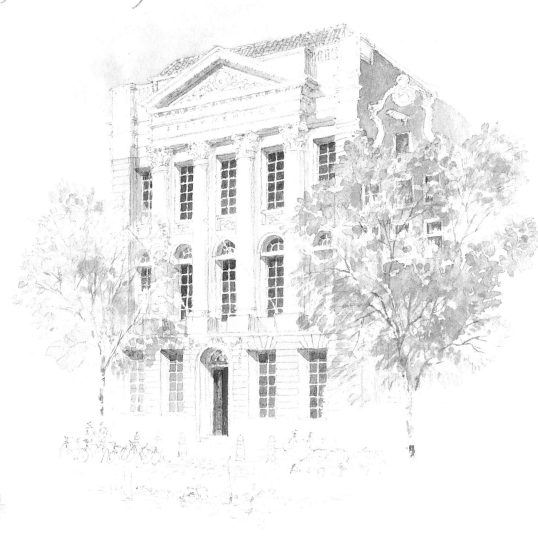

Built at the end of the 19th century, the Krijtberg is a Catholic church in the Gothic-revival style, which is rare in the Netherlands. It was built on the site of a 17th-century house church established in a warehouse known as the Krijtberg. Johannes Laurentius, a Jesuit priest, openly conducted Catholic services in this house church.

Gable stone with the inscription, literally translated, 'In the crowned emperor's boot.'

Decorative iron cramps can be seen on many houses in Amsterdam. They act as supports to walls.

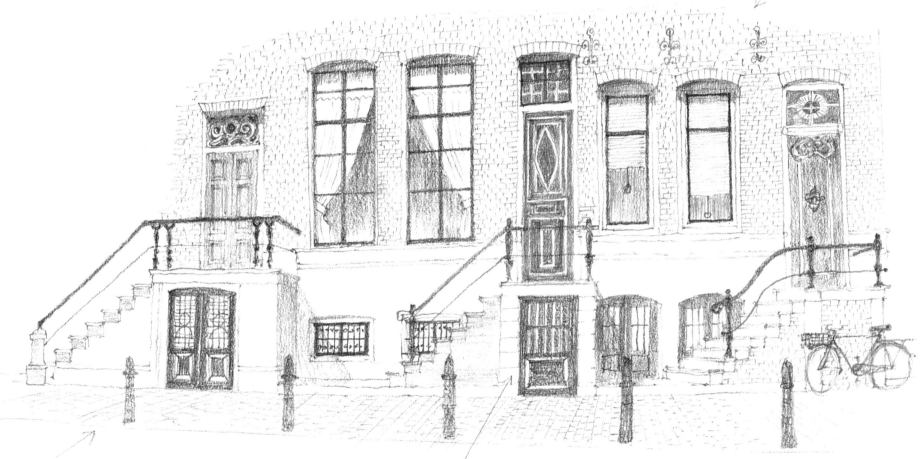

The bollard was introduced in the 20th century to prevent cars from parking on the pavement. They are known as 'Little Amsterdammers' and bear the three crosses of St Andrew, also found on Amsterdam's coat of arms.

Here on Keizergracht are a couple of good examples of Amsterdam doorsteps made of natural stone that lead up to the main door. The elevated entrance and doorsteps are necessary because basements could not be constructed too deep due to the high water table. The basements, half below, half above street level, are known as souterrains. The doors to the souterrain are also partly below street level and are accessed by going down a few steps.

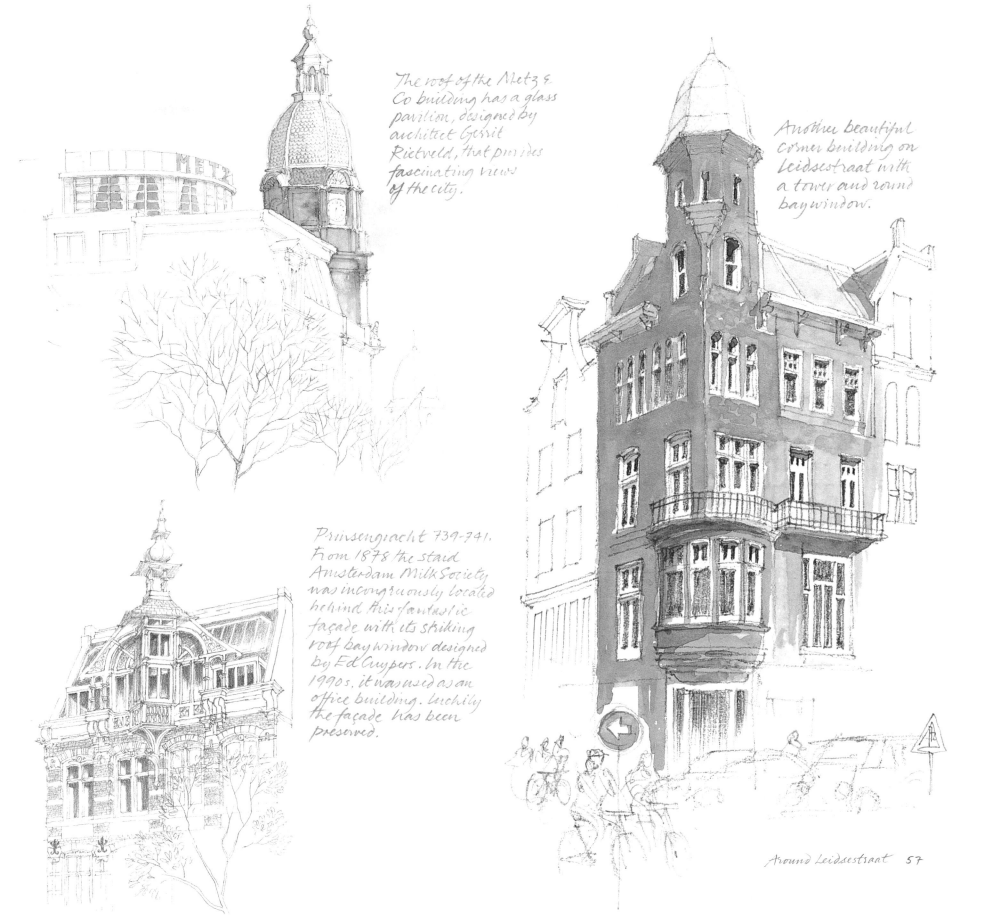

The roof of the Metz & Co building has a glass pavilion, designed by architect Gerrit Rietveld, that provides fascinating views of the city.

Another beautiful corner building on Leidsestraat with a tower and round bay window.

Prinsengracht 739-741. From 1878 the staid Amsterdam Milk Society was incongruously located behind this fantastic façade with its striking roof bay window designed by Ed Cuypers. In the 1990s, it was used as an office building. Luckily the façade has been preserved.

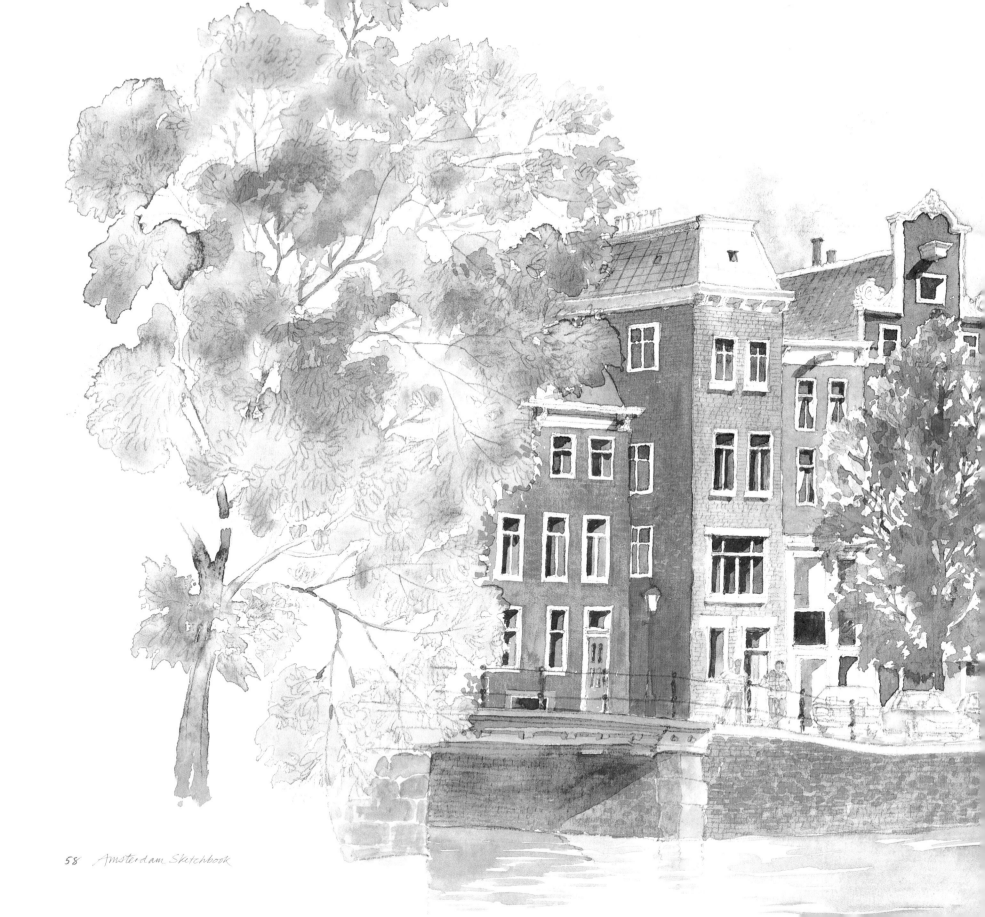

A row of canal houses on the Singel dating from different periods.
Often the upper façades are still in their original condition, but
most of the lower parts have been greatly altered over the years. The
19th century saw the removal of many doorsteps because people
found them to be in the way. Or, as can be seen in a
number of houses here, the lower façades have
been rebuilt to accommodate shops or cafés.

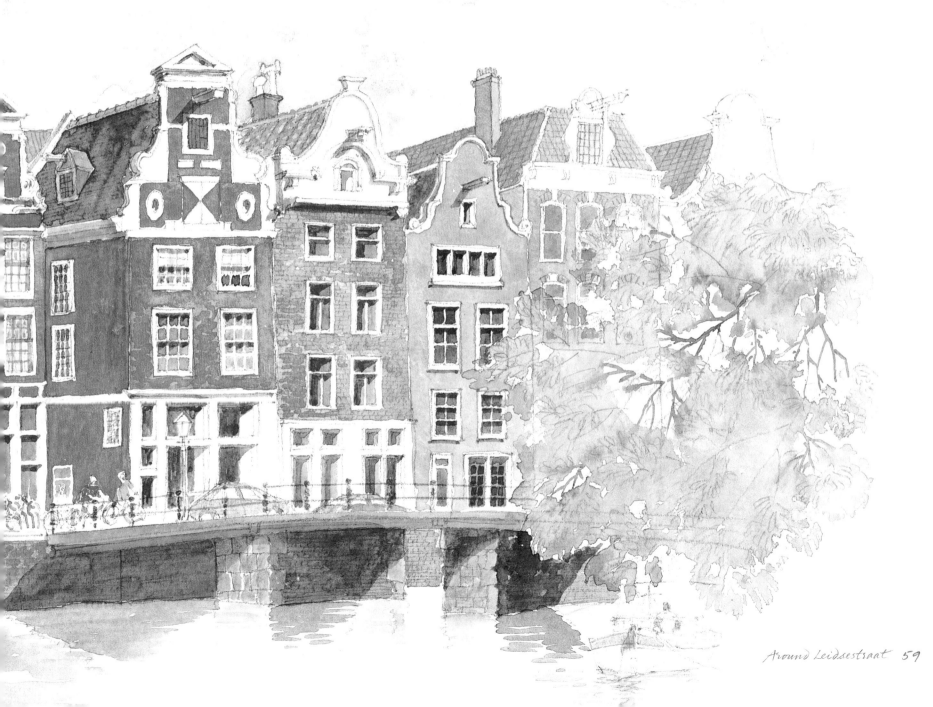

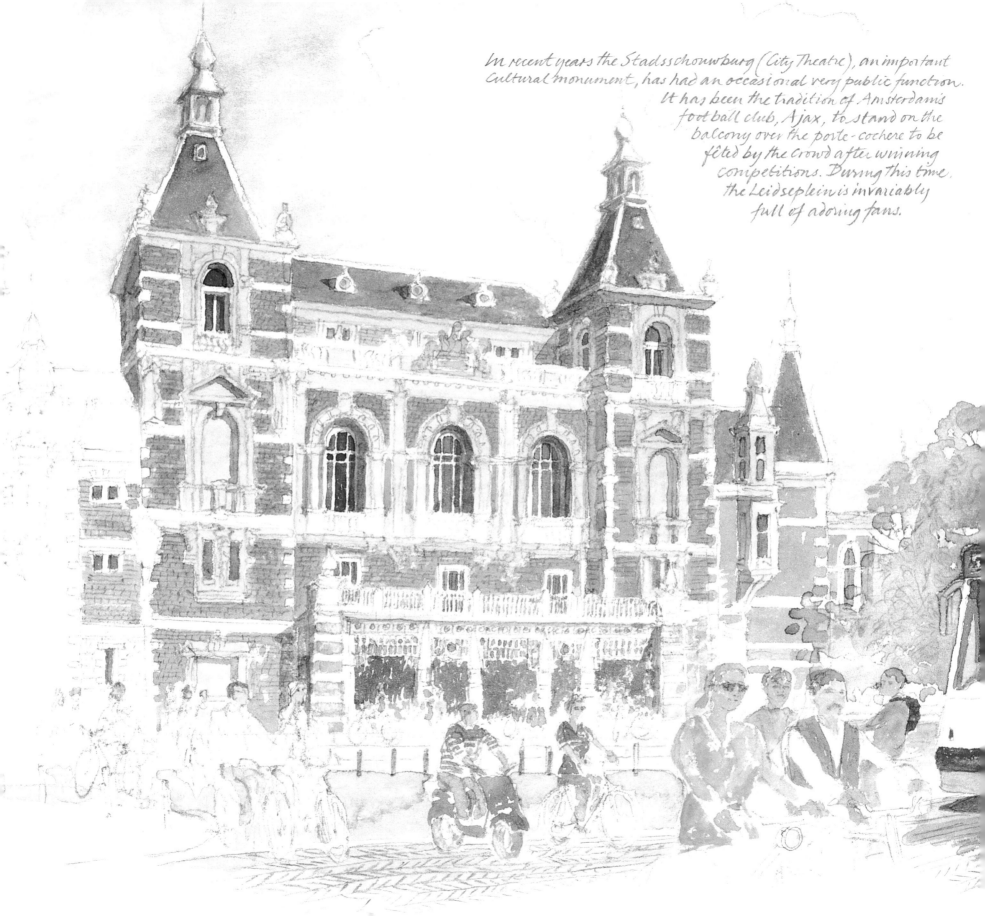

In recent years the Stadsschouwburg (City Theatre), an important cultural monument, has had an occasional very public function. It has been the tradition of Amsterdam's football club, Ajax, to stand on the balcony over the porte-cochère to be fêted by the crowd after winning competitions. During this time, the Leidseplein is invariably full of adoring fans.

Bicycles of different shapes and forms, transporting a variety of things, can be seen all over Amsterdam.

Musicians and other performers enliven the cafes that are set up annually from 1st March to 1st November.

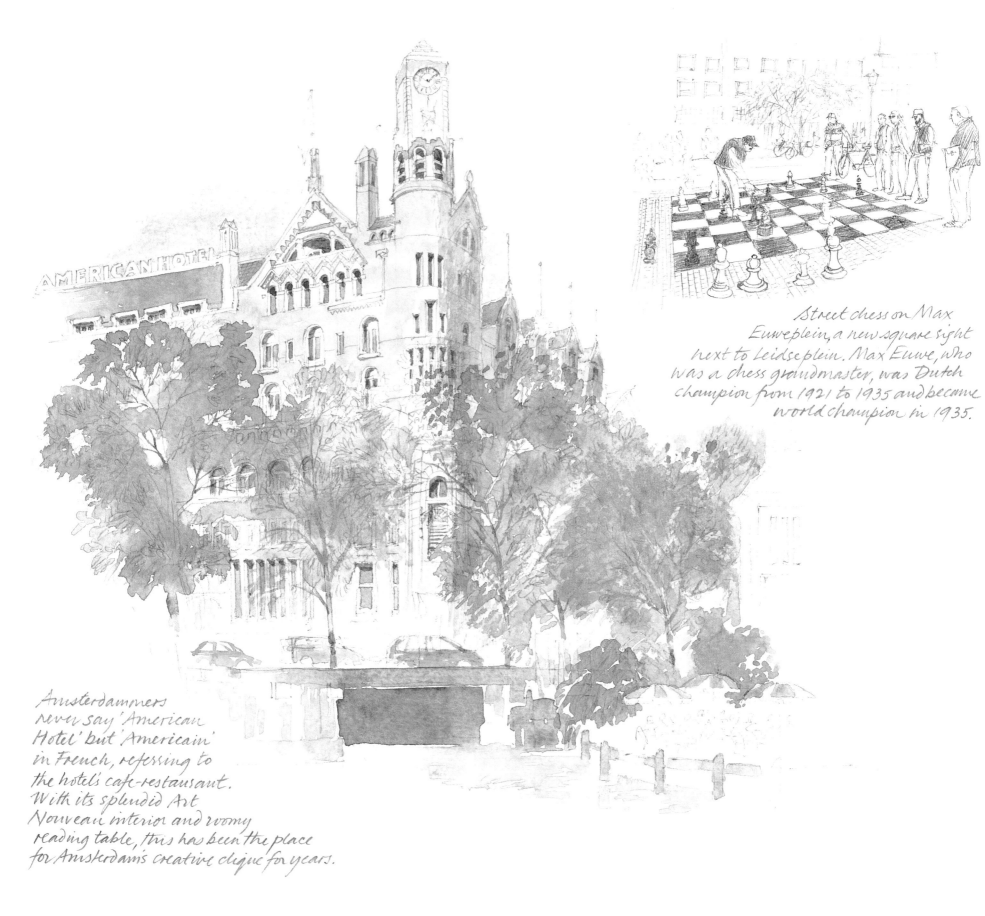

Street chess on Max Euweplein, a new square sight next to Leidseplein. Max Euwe, who was a chess grandmaster, was Dutch champion from 1921 to 1935 and became world champion in 1935.

Amsterdammers never say 'American Hotel' but 'Americain' in French, referring to the hotel's cafe-restaurant. With its splendid Art Nouveau interior and roomy reading table, this has been the place for Amsterdam's creative clique for years.

The 'Bulldog', a large coffee shop on
Leidseplein, is very popular with young tourists.
Apart from coffee, hash can be bought and
smoked. Few have any idea that this building
used to be Police Station Number 14.

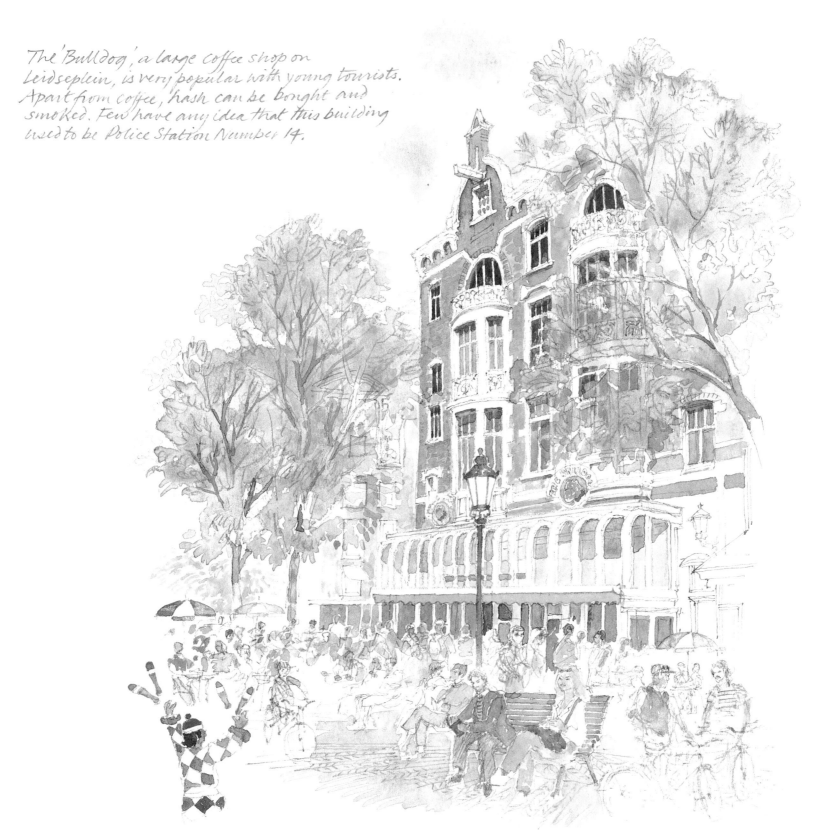

Around Rembrandtplein and Vijzelstraat

This richly decorated entrance, reputed to be one of the most beautiful in Amsterdam, opens into the Willet-Holthuysen Museum on Herengracht.

From Muntplein, with its charming Munttoren (Mint Tower), two streets run in an easterly direction. The most easterly, Reguliersbreestraat, runs in the direction of Rembrandtplein. Rembrandtplein was originally a 'wagon square', a parking area outside the city gate for horses and large wagons that came from outside of Amsterdam and that were not allowed inside the city. After that it was used for centuries as a market place. In the last quarter of the 19th century it was full of entertainment places, with large hotels and restaurants, and in the surrounding area, theatres and cabarets. Amsterdammers would sit at the terraces of cafés to watch the comings and goings. It became particularly festive with the opening of the Tuschinski Theatre in 1921. No longer quite the centre of popular entertainment it once was, Rembrandtplein remains lively today.

A stone's throw from Rembrandtplein is the Willet-Holthuysen Museum on Herengracht, one of the few canal houses open to the public. The Museum van Loon is on Keizersgracht near Vijzelstraat. Just like the Willet-Holthuysen Museum, it occupies a 17th-century double-sized canal house.

Life on the canals had its downside in earlier centuries. The water tended to become foul, especially in the summer when the stench got unbearable. Those who could do so, fled the city as early as May. Everybody threw their rubbish into the canals, as did factories, including dye houses and tanneries. Worse, the canals were used as sewers.

In the 17th century, a system was set up for the water in the canals to be refreshed regularly. Fresh water would come in from the IJ when it was in flood, circulate in the canals and flow out at low tide. Clean water from the Amstel was concurrently circulated in a similar way. Sluice gates, at that time hand-operated, had to be used as the canals were of different levels. In the late 19th century, steam-powered pumps were put in place.

The Willet-Holthuysen Museum has an
attractive garden in early 18th-century style. Visitors
are often suprised that a lot of canal houses
have such spacious gardens.

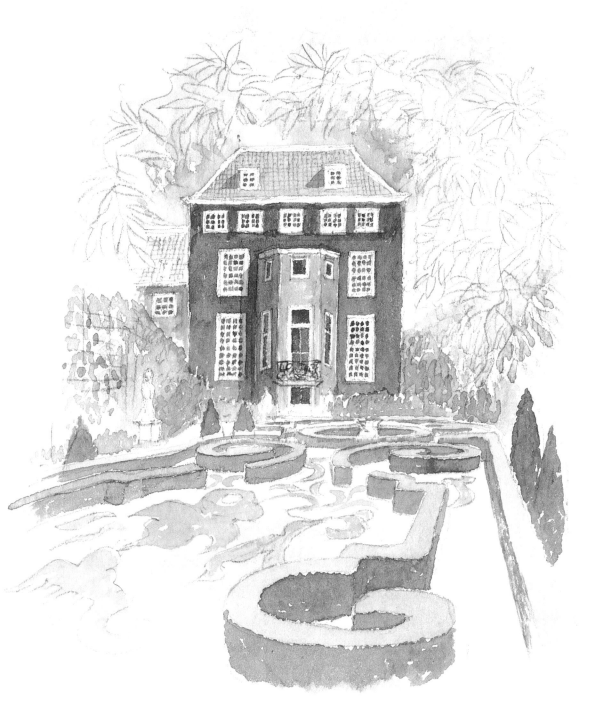

At the end of the Van Loon Museum's
lovely garden stands an original coach house.
Horses and coaches entered the
coach house from the street.

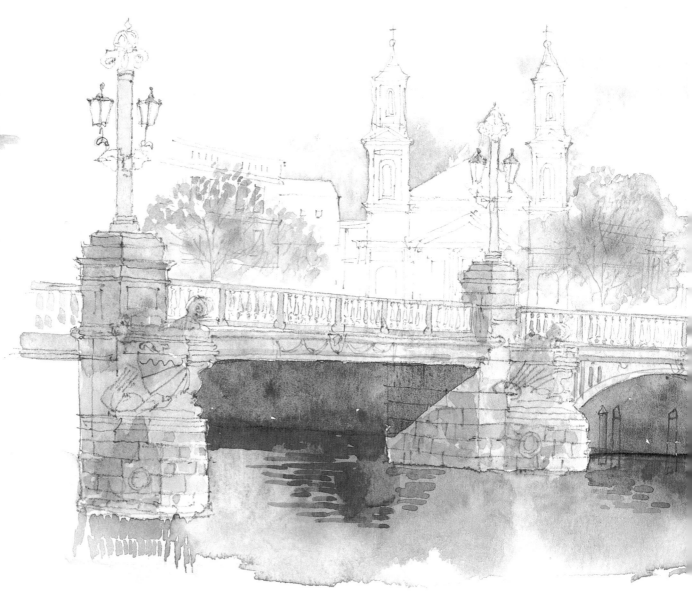

The Blauwbrug, which spans the River Amstel, is one of the finest bridges in Amsterdam. This bridge 'with Parisian allure', completed in 1884, was designed by W.H. Springer and B. de Greef. The two imposing towers of the Mozes and Aäron Church on Waterlooplein can be seen in the background.

The lantern standards on the Blauwbrug take the form of ships' prows, and are topped with the imperial crown.

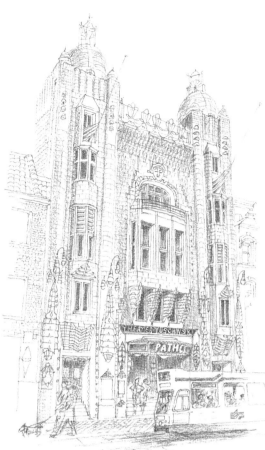

The base of the Munttoren (Mint Tower) dates from the Middle Ages and was part of a city gate. In 1620, the octagonal upper structure, with open ornamental peaks, was added. The tower stands on busy Muntplein, where part of the famous flower market on the Singel is also located.

Designed by H.L. de Jong in 1921. The Tuschinski Theater building is a gaudy mixture of styles: Art Deco, Art Nouveau, Amsterdam School, Jugendstil.

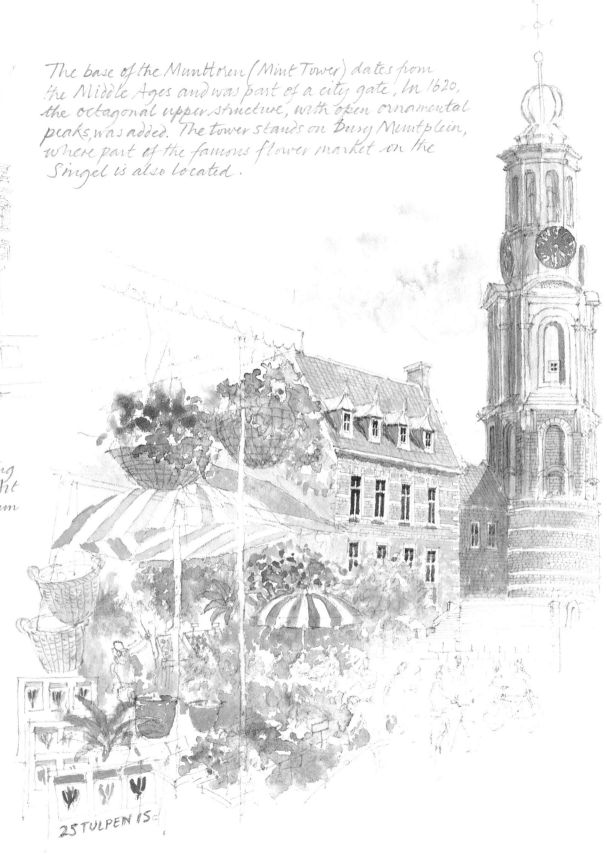

25 TULPEN 15

Rembrandtplein doesn't have many old buildings any more, but the house on the corner still has its original gable. It is a very popular area for cafés, bars and restaurants. And a fine statue of Rembrandt stands in the centre of the square.

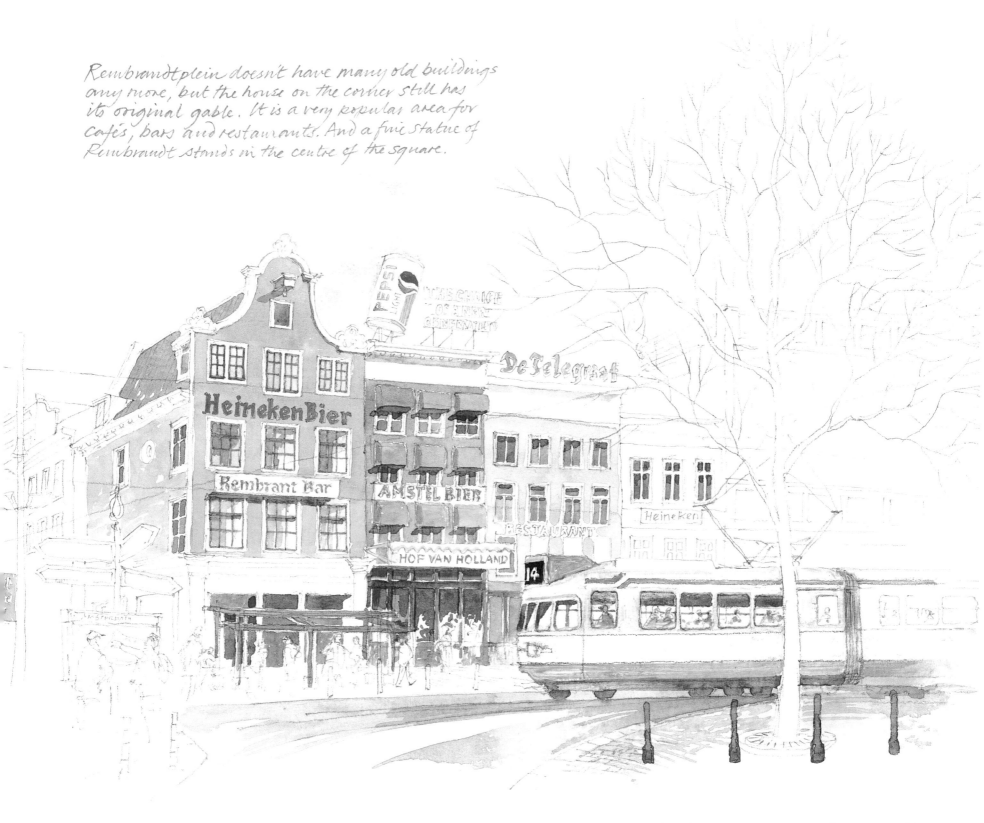

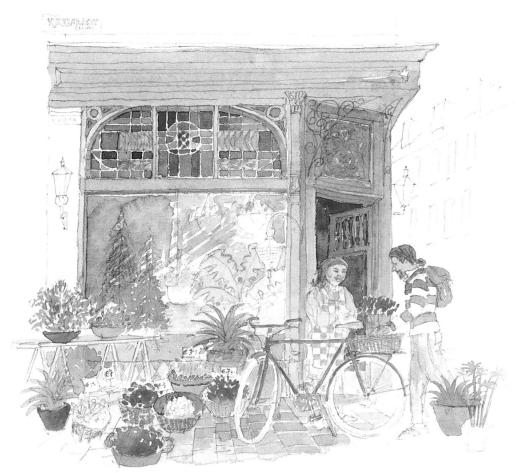

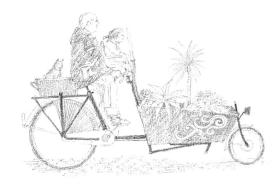

Amsterdammers' bikes come in all sorts of shapes and sizes. This one is a long wheelbase model that takes everything from plants, animals and children all at once.

This shop's premises on Vijzelgracht is well known to Amsterdammers for being the place where the butcher Rodrigues, famous for his hand-made pâtés, started his shop in the 1960s. The shop closed a few years ago. But its now a florist of which there are many in the city.

One of the many cafés that look out onto Rembrandtplein. In winter they are warm and welcoming, whilst in summer you can sit outside in the sunshine and watch the world go by.

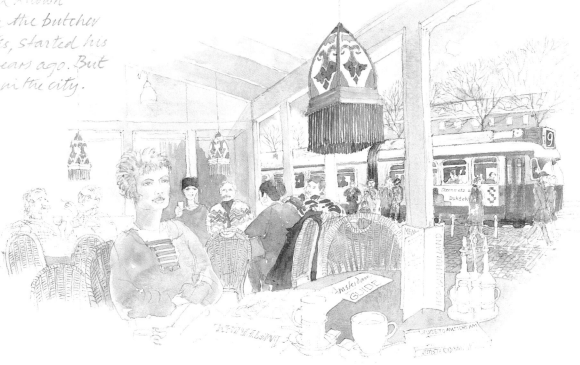

The richly ornamented houses on Weteringschans (above and below left) were built around the 1900s. The street borders the 17th-century Wetering neighbourhood, where there are still a lot of original houses (below).

The famous Magere Brug (Skinny Bridge) crosses the Amstel River. It is a wooden drawbridge with nine structural bays. Larger ships can sail through the middle, where the bridge can open. The Magere Brug has had a number of predecessors. The present bridge dates from 1934.

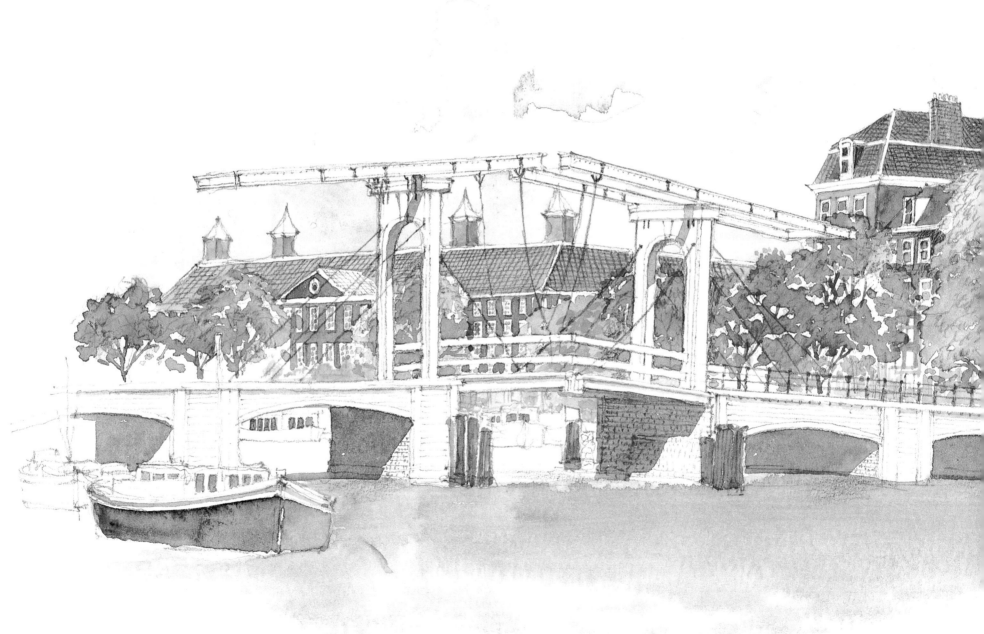

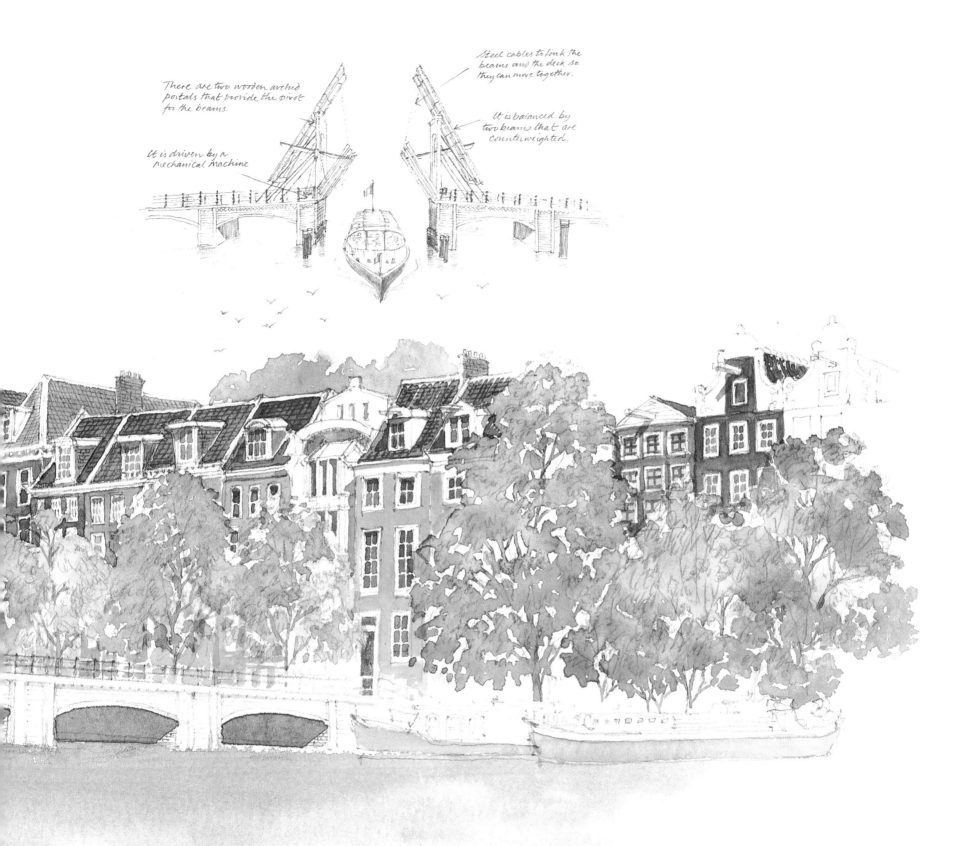

There are two wooden arched portals that provide the pivot for the beams.

Steel cables to link the beams and the deck so they can move together.

It is driven by a mechanical machine

It is balanced by two beams that are counterweighted.

IJ, Amstel and Plantage

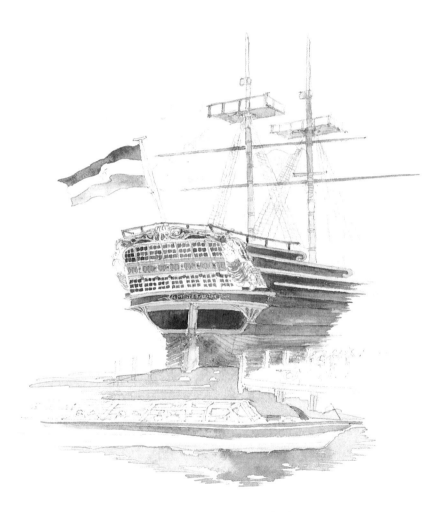

The full-scale replica of the VOC ship 'Amsterdam' is part of the Scheepvaart Museum's collection and is open to the public.

The view along the southern end the Amstel River, where the river is very wide, is breathtaking. There were many places for recreation here, past the 17th-century city borders; still farther south lay 17th- and 18th-century country mansions, some of which can still be seen. In summer, the rich fled here to escape the smell of the city.

There are a number of large buildings along the Amstel, such as the Koninklijk Theater Carré, which was built in 1887 by circus owner Oscar Carré. It is a large theatre; today the most remarkable performances are the ones where a solo performer stands alone on that immense stage.

Plantage, another favourite area for leisure, became part of the city after the great extension in the second half of the 17th century. However, Amsterdam's population did not increase as much as anticipated, and so this became a large green, planted with elms and linden trees, traversed by straight paths. The paths and roads were ideal for strollers, for riding in coaches or carriages, for horse races and, in the winter, for sledge competitions, where the sledges were pulled by horses. The Hortus Botanicus (Botanical Garden), which dates from 1638, was transferred here. By the 18th century many tea houses, bars and pubs sprouted here, giving the Plantage a reputation for all-night entertainment.

In the 1840s on an existing country estate, a zoo was set up in Plantage by an association, the Natura Artis Magistra, whose name means 'nature is the inspiration for art'. It was a success, however, initially one had to be a member of the association to visit the zoo. The leafy garden was not only a centre for nature appreciation, but also for science. Concerts and lectures were held, and a great exhibition space was built here, filled with various natural curiosities and stuffed animals. The zoo still retains some of its 19th-century character, but keeps up with the times and houses the animals in as natural a habitat as possible.

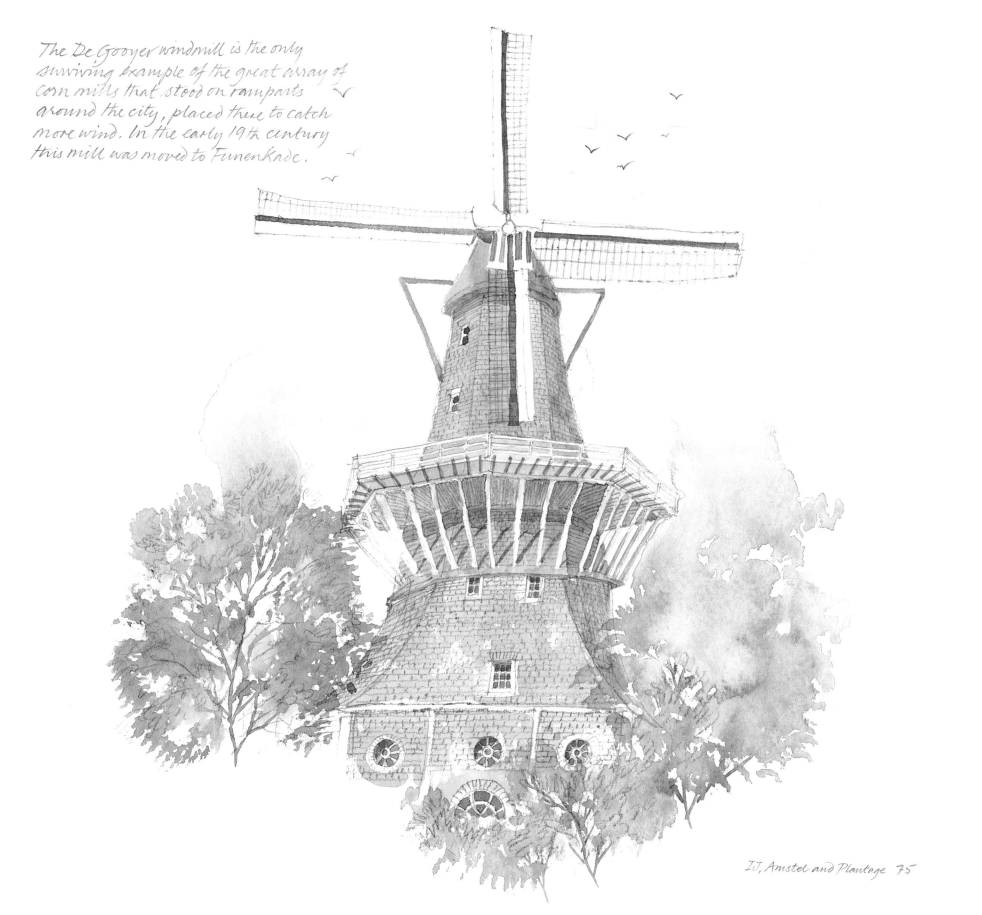

The De Gooyer windmill is the only
surviving example of the great array of
corn mills that stood on ramparts
around the city, placed there to catch
more wind. In the early 19th century
this mill was moved to Funenkade.

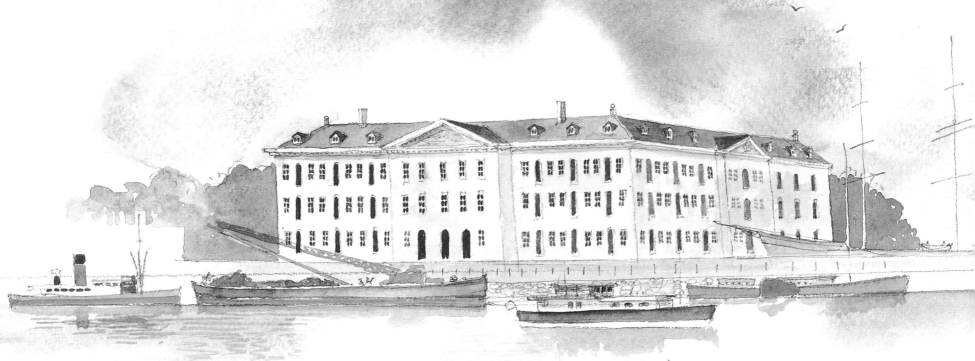

The Scheepvaart Museum is housed in the imposing's Lands Zeemagazijn building that belonged to the Admiralty of Amsterdam. Goods needed to equip the naval fleet were once stored here. The building's square plan is arranged around a handsome courtyard.

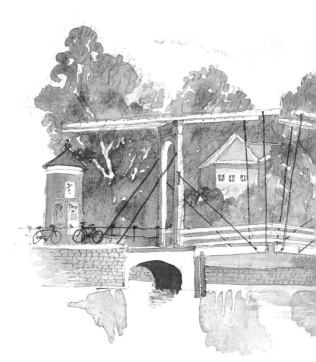

A beautifully sculptured and painted figurehead of one of the sailing ships in the harbour.

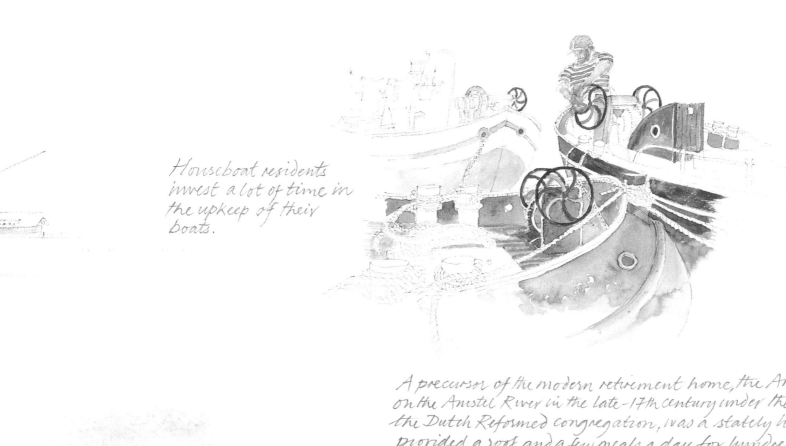

Houseboat residents invest a lot of time in the upkeep of their boats.

A precursor of the modern retirement home, the Amstelhof, built on the Amstel River in the late-17th century under the auspices of the Dutch Reformed congregation, was a stately house that provided a roof and a few meals a day for hundreds of elderly single men and women.

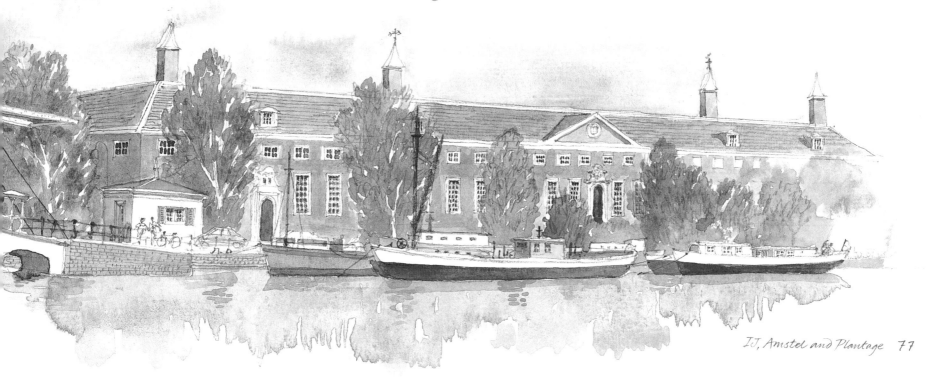

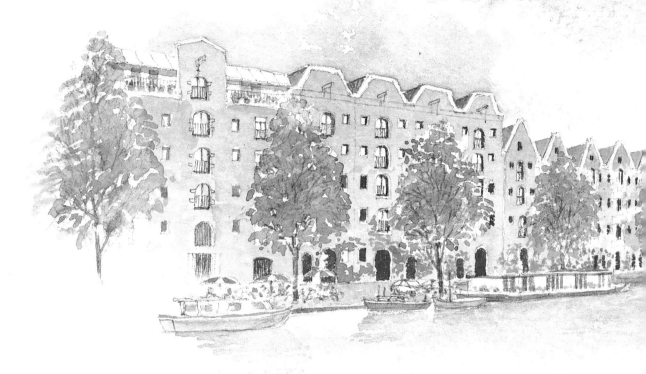

The grand Entrepotdok, consisting entirely of warehouses, came into being in 1840. This impressive row was made over to residential use at the end of the 20th century. The people who now live here have a great view of the Artis Zoo.

A nice painted decoration on a side gable of a house that stands on the junction of the Plantage Middenlaan and the Plantge Kerklaan. It is a fine example of street art that is so popular in Amsterdam.

The golden eagles have guarded the entrance to Artis Zoo for over a century and a half.

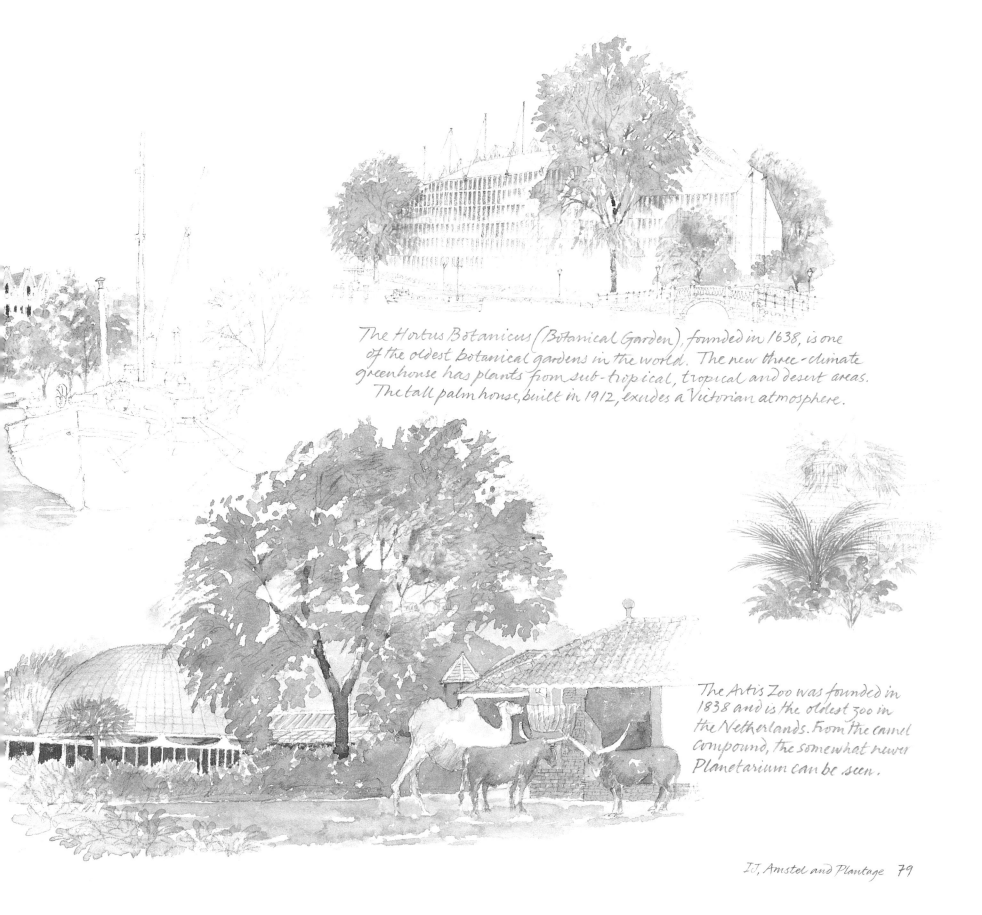

The Hortus Botanicus (Botanical Garden), founded in 1638, is one of the oldest botanical gardens in the world. The new three-climate greenhouse has plants from sub-tropical, tropical and desert areas. The tall palm house, built in 1912, exudes a Victorian atmosphere.

The Artis Zoo was founded in 1838 and is the oldest zoo in the Netherlands. From the camel compound, the somewhat newer Planetarium can be seen.

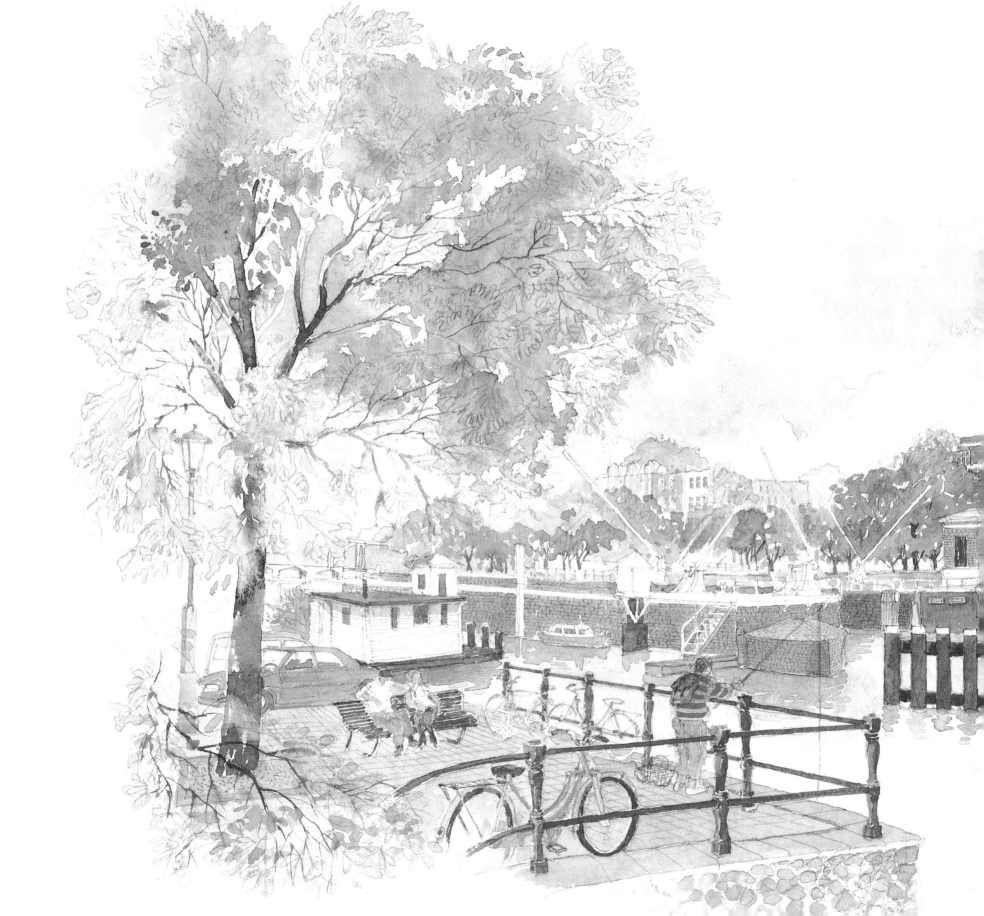

One of the two city gates that kept their function is the
Muiderpoort. When the Netherlands became a part of the
French Empire in 1810, Napoleon visited Amsterdam a
year later. Outside the Muiderpoort, he received the keys
to the city, and rode through the gate to 'his' third
capital city.

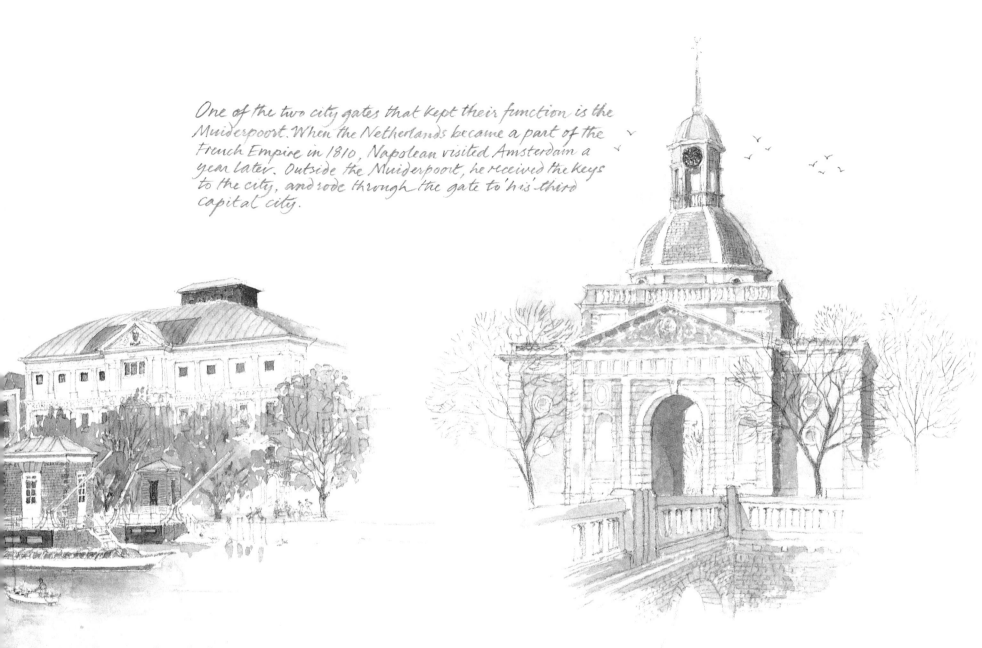

The locks on the Amstel River were put in place in 1673 to help
regulate the flow of water in the city's canals and allow the
exchange of the water with the IJ. The Carré Theatre can
be seen in the background to the right.

Museum Quarter and Vondelpark

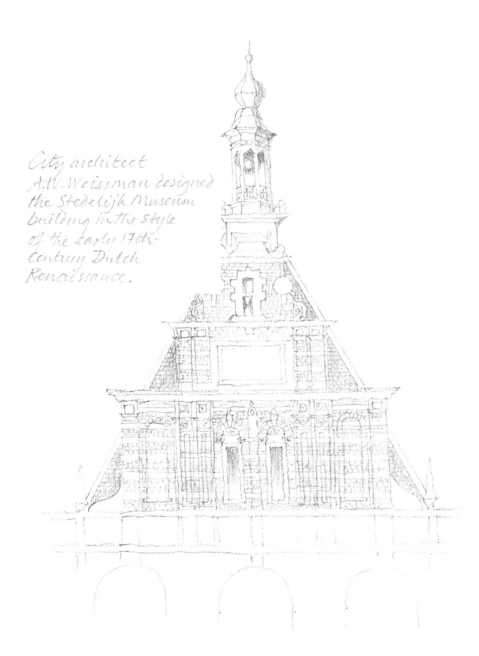

City architect
A.W. Weissman designed
the Stedelijk Museum
building in the style
of the early 17th-
century Dutch
Renaissance.

The Museum Quarter is a neighbourhood for the well-to-do, with the most expensive shopping streets in Amsterdam: P.C. Hooftstraat and Van Baerlestraat. The neighbourhood came into being around 1900 after three temples of culture were erected here, of which the Rijksmuseum was the first. The museum's huge building with its prominent towers facing the old inner city was located at the end of Spiegelgracht, which has many fine antique shops. Opposite the rear of the Rijksmuseum, at a distance of about 500 metres, is the Concertgebouw (Concert Hall) which had its inaugural concert in 1888. The last temple of culture of the time, the Stedelijk Museum, was built on Paulus Potterstraat in the 1890s.

Amsterdam's city planners always struggled with the space behind the two museums and in front of the Concert Hall. The Museumplein, as it is called, was used from 1880 to 1940 by the Amsterdam Skate Club and for large-scale events, but it never achieved the warm atmosphere other squares in Amsterdam have. Up until the 1950s, it still was dotted with bunkers from World War II. The Van Gogh Museum, built in 1973, gave the square a more modern look and attracted a lot more visitors. At the end of the 1990s, the square was redesigned by Danish architect Sven-Ingvar Andersson. He created a large green space, with a lot of benches and a pond on which people could again skate when it is frozen during the winter. However, as always, Amsterdammers had mixed feelings about the new design for the Museumplein.

The Vondelpark, like other big projects in the 19th century, was privately sponsored. Many Amsterdammers contributed to this green lung, which although narrow, is 2 kilometres long. The park is enjoyed by strollers, cyclists and many, many rollerskaters. The park is also great for picnics, family gatherings and parties.

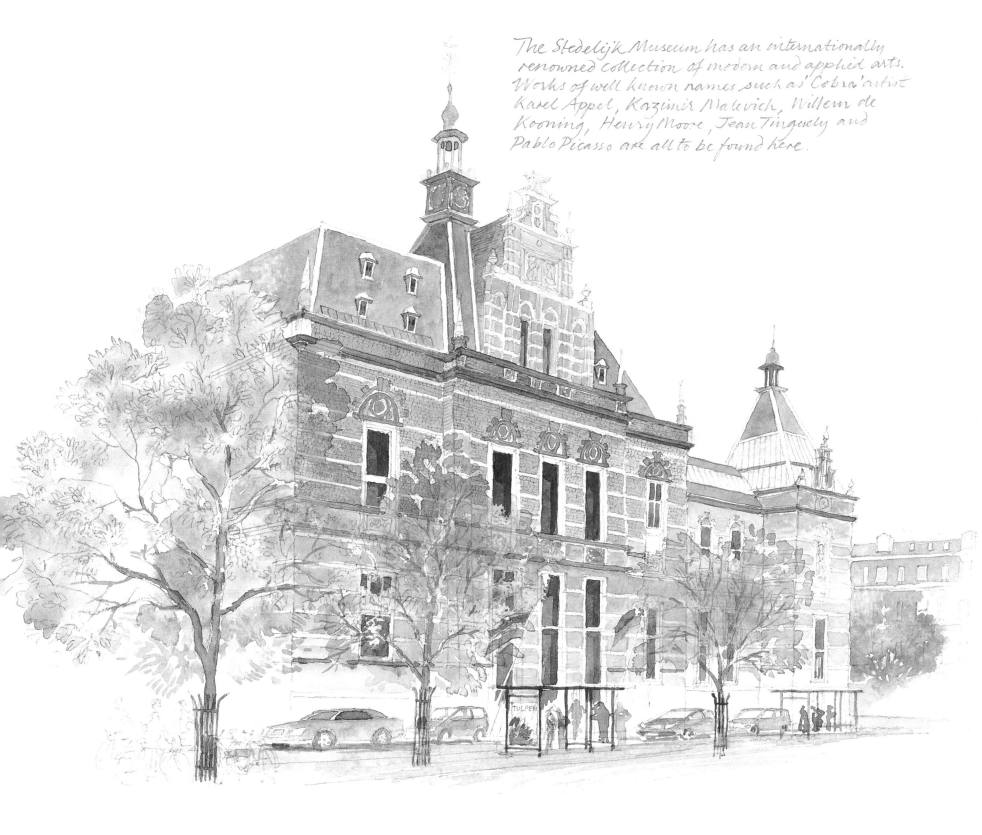

The Stedelijk Museum has an internationally renowned collection of modern and applied arts. Works of well known names such as 'Cobra' artist Karel Appel, Kazimir Malevich, Willem de Kooning, Henry Moore, Jean Tinguely and Pablo Picasso are all to be found here.

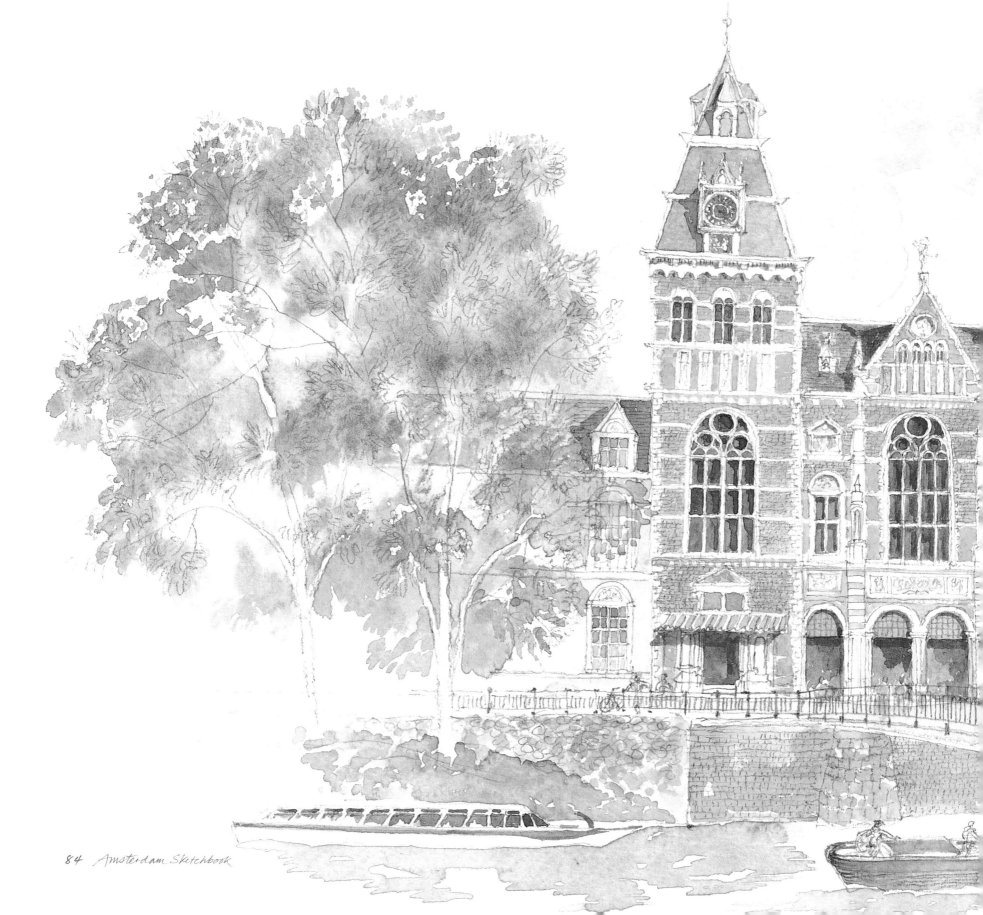

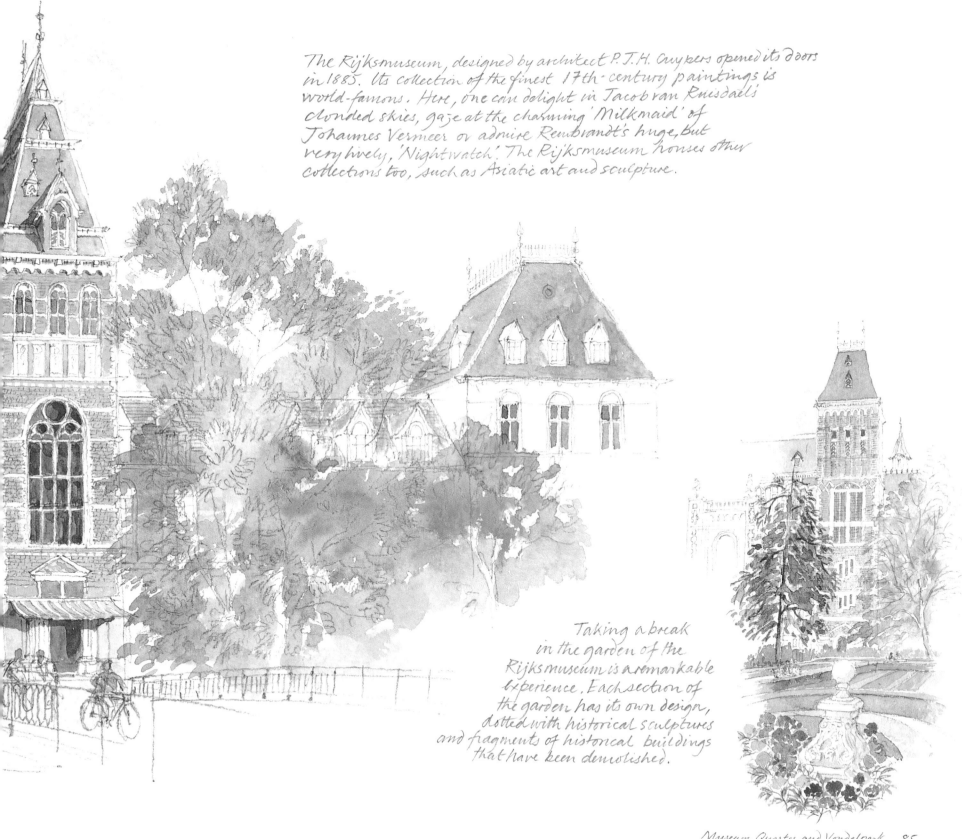

The Rijksmuseum, designed by architect P.J.H. Cuypers opened its doors in 1885. Its collection of the finest 17th-century paintings is world-famous. Here, one can delight in Jacob van Ruisdael's clouded skies, gaze at the charming 'Milkmaid' of Johannes Vermeer or admire Rembrandt's huge, but very lively, 'Nightwatch'. The Rijksmuseum houses other collections too, such as Asiatic art and sculpture.

Taking a break in the garden of the Rijksmuseum is a remarkable experience. Each section of the garden has its own design, dotted with historical sculptures and fragments of historical buildings that have been demolished.

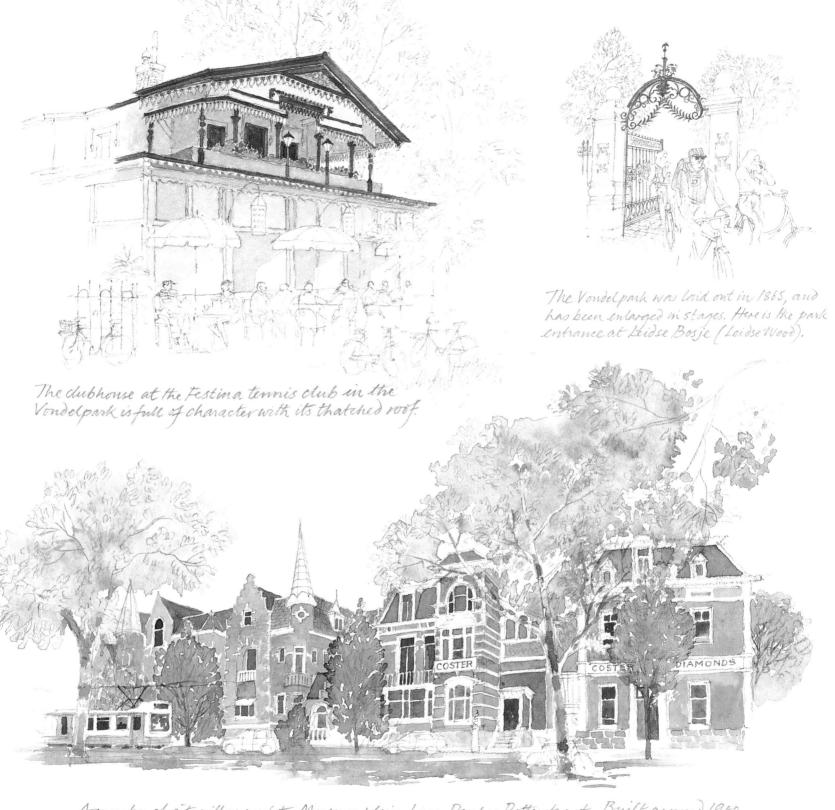

The Vondelpark was laid out in 1865, and has been enlarged in stages. Here is the park entrance at Leidse Bosje (Leidse Wood).

The clubhouse at the Festina tennis club in the Vondelpark is full of character with its thatched roof.

A number of city villas next to Museumplein line Paulus Potterstraat. Built around 1900 for wealthy Amsterdammers, these villas are now priceless. Companies such as Coster Diamonds, have established themselves here and keep the houses in excellent condition.

The Pavilion in the Vondelpark is built in the Italian Renaissance style.
The building dates from 1881 and is home to the Film Museum and
Café Vertigo. The spacious terrace of the café is extremely popular.
It has a fine view over a small lake.

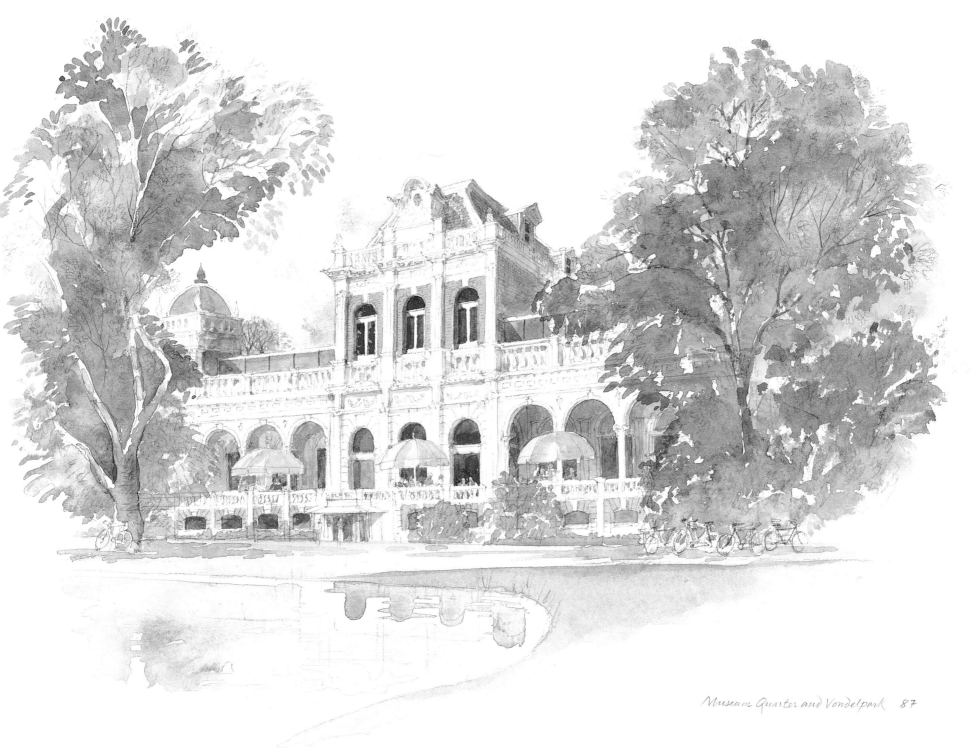

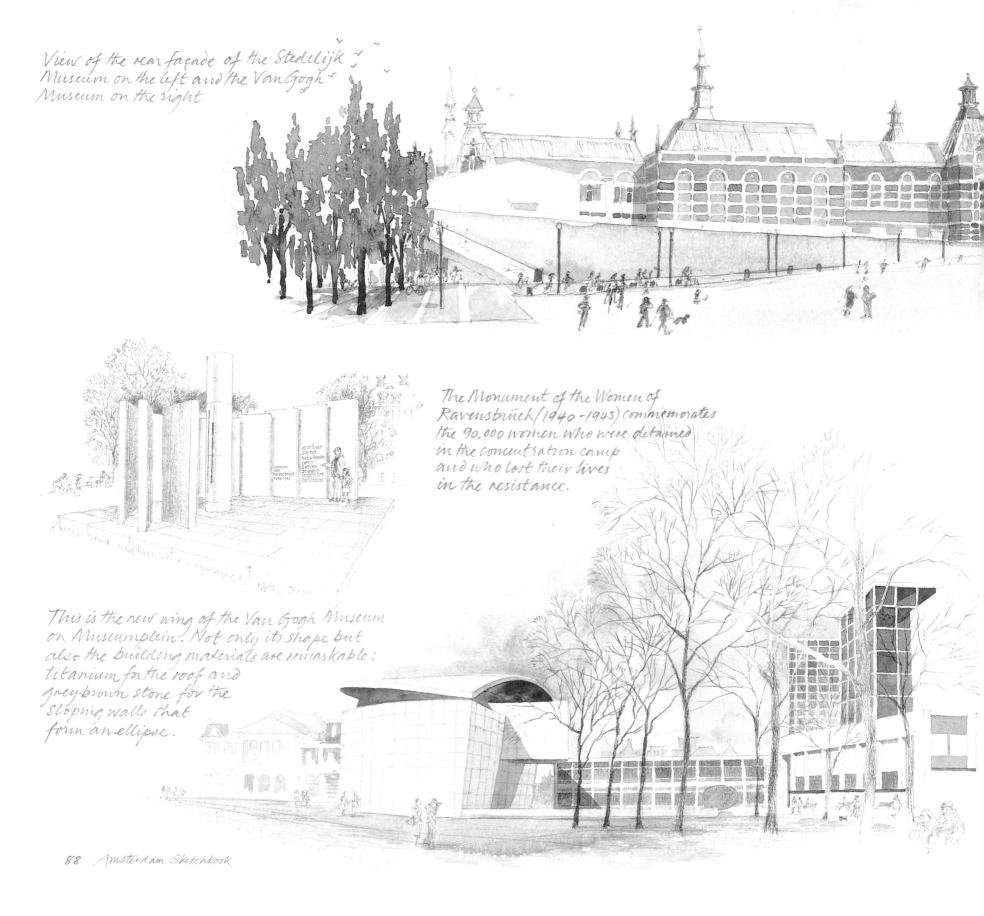

View of the rear façade of the Stedelijk
Museum on the left and the Van Gogh
Museum on the right

The Monument of the Women of
Ravensbrück (1940-1945) commemorates
the 90,000 women who were detained
in the concentration camp
and who lost their lives
in the resistance.

This is the new wing of the Van Gogh Museum
on Museumplein. Not only its shape but
also the building materials are remarkable:
titanium for the roof and
grey-brown stone for the
sloping walls that
form an ellipse.

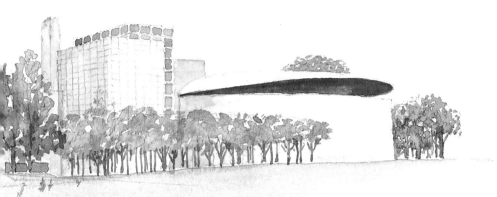

The Concertgebouw (Concert Hall) building
was made in what was called in the 19th century
the Viennese Renaissance style. It is a combination
of neoclassical and neorenaissance styles. Near perfect
acoustics benefit the many famous orchestras
and musicians who perform here.

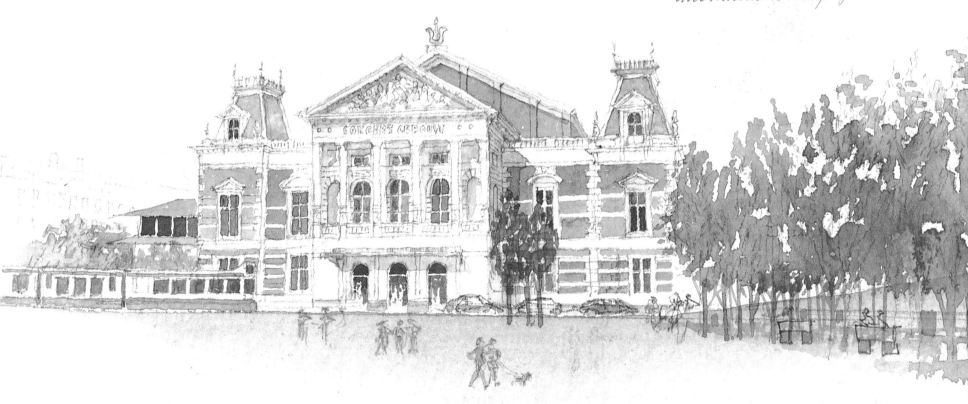

Gazetteer

Page 7
Central Station, Stationsplein

The design commission for Centraal Station was assigned in 1879, presumably first to AL van Gendt (1835–1901). Van Gendt was later joined by PJH Cuypers (1827–1921), who put his stamp on the building by giving it a Dutch neo-Renaissance look. Numerous artists worked on the decorations of the station, which became operational in 1889. Due to frequent renovations, a great part of the station's original interior has been lost.

Page 8
Oude Kerk (Old Church), Oudekerksplein

The first stone church in Amsterdam was built in the second half of the 13th century. This simple church was, after 1300, superseded by a more spacious one that was dedicated to Saint Nicolas. Within the next century and a half, the building grew into a three-nave church with 13 chapels, a number of altars and a tower designed by stonemason Joost Jansz Bilhamer (1541–1590). After the political upheaval of 1578, it was made ready for reformed services. There are nevertheless several sculptures from before 1578 that can still be seen. During the extensive restoration from 1955 to 1978, paintings were found on walls and within vaults. Until 1892, the Oude Kerk also functioned as an archive. In the south nave, about 5 metres above ground, is the door to the 'Iron Chapel', where the most important documents of the city were kept.

Page 10
Bartolotti House, Herengracht 170–172

Reportedly designed by city master builder Hendrick de Keyser (1565–1621), this city-palace was built as the living and business premises of Willem van den Heuvel. By the time the house was completed in 1621, van den Heuvel had amassed a fortune as a brewer. When he became the head of the Bartolotti trading and banking house through inheritance, he came to be known as Guillelmo Bartolotti. The family lived in this house until 1689, after which the building was divided into two and got a second entrance. The house was given a thorough restoration from 1967 to 1971. Currently, a part of this stately canal house is open to the public and is home to the Theater Instituut Nederland.

Page 17
Het Schip (The Ship), Spaarndammerplantsoen 140

Architect Michel de Klerk (1884–1923) designed a housing block on the Spaarndammerplantsoen for the Eigen Haard housing association. It was built in 1917–1921. With its expressive and sculptural styling, it proved to be one of the most characteristic structures of the Amsterdam School. The building got the nickname Het Schip (The Ship) due to its distinctive shape.

Page 18
Het Scheepvaarthuis (The Shipping House), Prins Hendrikkade 108–114

From 1910 a new architectural style developed in Amsterdam, which in 1916 was named the 'Amsterdam School'. The construction of Het Scheepvaarthuis, which was to become the most important building of the Amsterdam School, began in 1913 and was completed in three years. This office building on the Prins Hendrikkade, wherein six shipping companies would be located, was commissioned to the architectural practice of the Van Gendt brothers. Together with other artists, JM van der Mey (1878–1949) was responsible for the design of the façades and the interior. Het Scheepvaarthuis is now a hotel.

Page 19
Anne Frank House, Prinsengracht 263

No. 263 Prinsengracht is world famous. This is the house where, between 1942 and 1944, the Jewish girl Anne Frank and her family hid in an attempt to escape persecution by the German army, which had occupied the Netherlands. The office of the firm of Otto Frank, Anne's father, came to be located in this canal premises in 1940. In July 1942 Anne's immediate family hid in a secret annexe of the house until their hiding place was betrayed. The family was apprehended and was taken away. In March 1945, Anne died in the Bergen-Belsen concentration camp. She left a diary behind in Amsterdam, which was later published as *Het Achterhuis* (The Secret Annexe).

Page 20
Rembrandt House Museum, Jodenbreestraat 4

Rembrandt lived in a number of different locations in Amsterdam. The artist moved into this house in 1639, which was built in 1606–07. He stayed here until 1658, the year he had to auction it to settle his debts. By the end of the 19th century, the building had fallen into disrepair but it was successfully rescued from further damage by concerned Amsterdammers. A radical restoration by KPC de Bazel (1869–1923) followed. The dilapidated front and rear façades were rebuilt anew while the interior was renovated to facilitate the exhibition of drawings and prints. In 1911, the house was opened as a museum. In 1998, the exhibition was moved to the adjoining Saskiahuis. This created the opportunity to restore the interior of Rembrandt's former home. The restoration was completed in 1999.

Page 21
The Waag, Nieuwmarkt

The castle-like building of the Waag was originally a city gate. It is one of the few remnants of the defence structures that were laid down in the 15th century. Owing to the steady growth of the city, the gate became included within the city and lost its function. In 1617–1618, the ground floor was fitted out as a *waag* (weigh station). The open gate got a roof while a first floor was added to the building. Four guilds were located on this floor—the surgeons, painters, bricklayers and smiths. In 1690, a round, domed space was built on a second floor for anatomy lectures conducted by surgeons. This lecture theatre had a roof on which was painted the coat of arms of the surgeons, which has been preserved.

Page 22
Prinsenhof, Oudezijds Voorburgwal 197

At the end of the 16th century, the Admiralty of Amsterdam was located in a former convent that used to stand in this

location. The complex was also used as a guesthouse for visiting dignitaries. As the Admiralty expanded, the guesthouse was moved elsewhere in 1647. Thereafter, the main building for the Admiralty was erected. Though no longer a guesthouse, the new building continued to be referred to as the Prinsenhof (House of Princes). The strict front gable has a stone base and a handsomely decorated pediment. From 1808 to 1988, the Prinsenhof was used as the Amsterdam City Hall. In 1992 the complex was fitted out as a hotel, the very luxurious The Grand Amsterdam.

Page 22

Amstelkring Museum, Oudezijds Voorburgwal 40

The building which now houses the Amstelkring Museum was owned by Jan Hartman, who bought it in 1661. The Catholic trader used the front house and the two rear houses as his living quarters, a place of business and as a store for his goods. In addition, he established a church in the attic. At that time, the practicing of the Catholic faith in public was officially forbidden in Amsterdam. From the façade there was no sign that the house had a double function. This clandestine church—there were more of them in the city—remained in use until 1887. It is popularly known as 'Our Blessed Lord in the Attic'.

Page 23

Schreierstoren (Weepers' Tower), Prins Hendrikkade 95

Just like the Waag nearby, the Schreierstoren is a remnant of the defence structures built in the last quarter of the 15th century. With the exception of the windows that were installed in the 18th century to replace the slits in the walls from which shots could be fired, the building has not changed very much.

Page 23

The Coat of Arms of Riga, Oudezijds Voorburgwal 14

Wessel Becker, a trader from Riga (in present-day Lativa), registered for marriage in Amsterdam in 1604. He and his wife had a house built, which was for its time, considered large, albeit shallow. The house, completed in 1605, is a 'stoned' wooden house, with thin stone 'walls' that hang from the wooden skeleton of the house and have no structural function. The house was thoroughly restored by Jan de Meijer (1878–1950) in 1939–1940. The Dutch Renaissance step gable was reconstructed at that time, as was the wooden lower façade with its leaded-glass windows and scullery, so typical of the 17th century.

Page 26

Montelbaanstoren (Montelbaans Tower), Oude Schans

In the early 16th century, the Montelbaanstoren was built as a defence tower. It was disused by the end of the 16th century and was partially demolished. Only the base of the tower was left standing. In 1606 an octagonal, brick edifice was constructed upon the base. An open, wooden structure was placed on top of it. The wooden parts were clad in lead and subsequently painted in the colour of Bentheimer sandstone. This renovation gave the tower its present look.

Page 26

Oost-Indisch Huis (East India House), Oude Hoogstraat 24

The headquarters of the Verenigde Oost-Indische Compagnie (VOC) (East India Company) was located here from 1606 to 1798, when it was liquidated. A gate in the north wing of the complex, on the Oude Hoogstraat, opens into the courtyard, where the main building stands. The main building housed offices and meeting rooms. In the attics and cellars of the complex, provisions for the merchant ships were once stored. In the courtyard, sailors were mustered. The Oost-Indisch Huis is now part of the University of Amsterdam.

Page 28

Portuguese Synagogue, Jonas Daniël Meijerplein

This sober classical building with its front square surrounded by buildings for worship was inaugurated on 2 August 1675. The design of the front square and façade was based on a model of the Temple of Solomon, constructed earlier in Amsterdam by Rabbi Jacob Juda Leon in 1641. Whoever enters the main building steps back into the 17th century. Nothing in the interior has changed since 1675. Designed by Elias Bouman (1636–1686), the building's architectural layout became the standard for several synagogues in other parts of the world. The Portuguese Synagogue was thoroughly restored between 1978 and 1993.

Page 29

Joods Historisch Museum (Jewish Historical Museum), Nieuwe Amstelstraat 1

The building complex in which the Joods Historisch Museum has been occupying since 1987 was previously used, until World War II, as synagogues for the High-German (Ashkenazim) Jews who lived in Amsterdam. The complex dates from the 17th and 18th centuries and was built in four phases. De Grote Synagoge (Great Synagogue), inaugurated in 1671, was the first synagogue to be built. It was designed and constructed by master builder Daniël Stalpaert (1615–1676) and contractor Elias Bouman. Seventeen years later, another synagogue, the Obbene Shul came into use. Around 1700 a third synagogue, the Dritt Shul was constructed on an adjacent site. Finally, on 25 March 1752, the Nieuwe Synagoge opened its doors. The design is attributed to city master builder Gerard Frederik Meybaum. The municipality of Amsterdam took over the war-plundered buildings in 1954. Under the leadership of architect Jaap Schipper (1916–1991), extensive restoration was started in 1966 and was only completed in 1987.

Page 29

Stopera, Waterlooplein

'Lads, something must be done before long with the new opera building in Amsterdam: the model is on the verge of collapse,' joked cabaret artist Wim Kan in 1971. Amsterdammers had, by then, already been discussing the construction of an opera for nearly sixty years. It was not the only building that was talked about constantly in the city: the construction of the new City Hall had been discussed for at least as long. Both lingering questions were solved in 1971

with a plan from Wilhelm Holzbauer (b. 1930), a Viennese architect, to build the two together. In 1986, Holzbauer and Cees Dam (b.1932) completed the construction of a building where the Nederlandse Operastichting (Netherlands' Opera Foundation), the Nationaal Ballet, as well as the Amsterdam City Council could reside: the Stadhuis/Muziektheater, soon to be known as the 'Stopera'. Numerous artists contributed to the decorations of the interior.

Page 30

Amsterdams Historisch Museum, Kalverstraat 92

Visitors entering the Amsterdams Historisch Museum from the Kalverstraat have to walk through a colonnade along a small square and into a spacious courtyard. This is the same path the nuns of the Saint Lucien convent walked, in the 15th and 16th centuries, to reach the convent. After the political changes of 1578, the convent was dissolved and the complex became used as a civic orphanage. In 1581 a new gate, which is still in use, was built on the Kalverstraat by stonemason Joost Jansz Bilhamer (1541–1590). Due to the growth of the population and the proportional increase in the number of orphans, the orphanage was regularly rebuilt and extended. In 1960, the orphanage was moved to a new location elsewhere in the city. It was then decided to move the city's museum here. The renovation work to make the site suitable to be used as a museum was the most extensive in the history of the complex and was accomplished by architects Jaap Schipper (1916–1991) and Bart van Kasteel (1921–1988). A good part of the 18th-century exterior remains intact. A new addition is the unique, freely accessible 'museum street' between the former girls' and boys' complexes. Large group portraits of Amsterdam's civic guard from the 17th century are hung along the street. The Amsterdams Historisch Museum opened its doors on 27 October 1975.

Page 32

Sint-Nicolaaskerk, Prins Hendrikkade 74-77

Architect AC Bleijs (1842–1912) designed the Sint-Nicolaaskerk. It is a church with a front façade comprising two towers behind which is the central nave. The central nave is flanked by two side naves and is crossed by a transept. An octagonal tower, which is topped by a cupola rises above the middle of the nave and transept. The cross-shaped basilica was inaugurated on 7 February 1887. In the mix of styles that Bleijs employed, the neo-Renaissance and neo-Baroque elements predominate.

Page 33

De Goude en Silveren Spiegel (The Gold and Silver Mirror), Kattegat 4-6

These two identical houses with step gables date from 1614. They were named Goude en Silveren Spiegel because they were built for soap-maker Laurens Jansz Spiegel. The twin houses were built in the Dutch Renaissance style and their interiors have been preserved to this day. One of the houses even has its original fireplace.

Page 34

Koninklijk Paleis (Royal Palace), Dam

The Royal Palace on the Dam is the most important 17th-century monument in the Netherlands. It was built as the City Hall of Amsterdam between 1648 and 1665 and was used as such until 1808. The classical façade looks sober, but the building's sheer size is a display of the wealth and power of the city. Its composition is harmonious and complies with classical proportionings. Designed by Jacob van Campen (1596–1657), the building was constructed by city master builder Daniël Stalpaert. It is built from Bentheimer sandstone, which now, due to weathering, has become darker. This very light-coloured stone gave the City Hall a splendid appearance in earlier centuries. This can be clearly seen from the many old paintings that depict it. Van Campen's design comprised a rectangular floor plan with two square internal courtyards. At the heart of the building, on the first floor, the largest space is to be found: the *Burgerzaal*. The interior is spectacularly decorated with the use of a lot of marble. For the sculptures and paintings, elements from classical antiquity were chosen as themes—entirely in keeping with the building. The sculptures were by, amongst others, Artus Quellinus (1609–1668), a sculptor from Antwerp, and the paintings were by the best 17th-century masters, among whom were Ferdinand Bol (1616–1680) and Govaert Flinck (1615–1660). The international importance of the city can be appreciated in the impressive *Burgerzaal*, where in the floor mosaics, apart from the northern firmament, the western and eastern hemispheres of the world are inlaid, showing the shipping routes of the East- and West-India Companies. Similar references are also to be found on the exterior, such as the homage being paid by the sea gods to Amsterdam's power, portrayed on the front pediment. In 1808, King Louis Napoleon moved into the City Hall, and since that time, it has been a royal palace.

Page 34

Nieuwe Kerk (New Church), Dam

The construction of Nieuwe Kerk began around 1400. After the choir was finished, the church was enlarged. Over the years, 10 chapels were built and 34 altars were put in place. The church was also gradually made more alluring by affluent families that sponsored, for example, the leaded-glass windows. After the political changes of 1578, the building was used for reformed services. In 1645, a huge fire damaged the church and destroyed many artefacts. Many artists were involved in the restoration that followed. Their works are still worth seeing: the impressive pulpit of Albert Jansz Vinckenbrinck, the imposing copper choir screen of Janus Lutma, and the panels on the organ casing, designed by Jacob van Campen, and painted by Jan van Bronckhorst. The church building is now used for exhibitions and gatherings. On the annual 4th May commemoration of war victims, a memorial service is held here just before the wreath-laying ceremony at the Nationaal Monument on the Dam.

Page 35

Nationaal Monument, Dam

Plans for the construction of the Nationaal Monument on the Dam began in 1946, when public sentiments on the Occupation of 1940–1945 were sought. As early as January 1947 sculptor John Rädecker (1885–1956) was commissioned to design the monument. From mid-1948, he

was assisted by architect JJP Oud (1890–1963). In the middle of the monument, erected in concrete and travertine, stands a 22-metre obelisk on which, and beside which, groups of sculptures depicting war and peace are featured. Behind the monument, a curved wall was constructed. The wall incorporates eleven urns containing earth from mass execution sites and cemeteries from the then eleven provinces. A twelfth urn, filled with earth from a military cemetery in the former Dutch East Indies (present-day Indonesia), is also within the wall. The words depicted on the wall are by the poet Adriaan Ronald Holst. Rädecker's son, Jan Willem, carved the two lions in front of the monument. The challenge for Oud, the architect, was to make the different elements of the monument harmonise with each other and with Dam Square as a whole. On 4 May 1956, Queen Juliana unveiled the Nationaal Monument. Since that time, the monument had been thoroughly restored twice, in 1965 and in 1998.

Page 36
Beurs van Berlage, Damrak 277
The idea for a new building for the trading of goods and shares was mooted in 1870. The existing stock exchange building was too small and was increasingly unsuitable. After many discussions, and nearly 20 years later, it was the architect HP Berlage (1856–1934) who received the commission to design a new stock exchange building. The brick building was erected between 1898 and 1903. It contained three main trading halls surrounded by offices and service rooms. The largest hall was allocated for the trade of goods, and was where Berlage used red brick for the interior. The walls of the far smaller corn exchange were made of, rather appropriately, yellow stone. Berlage designed almost the entire interior of the building, including tables, chairs, lamps, and even hinges and door ornaments. Some distinguished artists, including Jan Toorop and Joseph Mendes da Costa, were invited to contribute to the building's decorations. The poet Albert Verwey came up with a design scheme for all the sculptures and chose the mottos that were to be placed on the walls. In contrast with the nearby Centraal Station, which is finished in the Dutch

neo-Renaissance style, the sobriety of Berlage's stock exchange stands out noticeably. It is precisely this subdued style that has given the building a prominent place in the development of Dutch architecture. Berlage was instrumental in the development of the growing conviction that the architect must move away from the then prevalent practice of florid embellishment. Over the years, the building was no longer the site of the stock exchange. Presently the halls are used more for events and concerts. Berlage's creation has remained largely intact. However, the building has had problems with its foundations. The 4,780 13-metre piles and the 100 10-metre ones that were originally installed, has turned out to be insufficient in preventing the monument from leaning over.

Pages 38–39
Begijnhof
Around 1300, a group of pious Catholic women established a community with the aim of living together in compliance with a set of devotional rules. They were known as the Begijnen. They formed a type of cloistered order, but since they were not nuns, they had more freedom. At the beginning, the women could all live in one house, but by the end of the 14th century, as the order grew, more houses around the courtyard had to be used by the Begijnen. The anti-Catholic measures that the city government undertook from 1578 largely left the Begijnen unaffected. They remained living in their own houses and even established a new chapel after their church, built in the middle of the courtyard, was given over by the city government to English Presbyterians in 1607 (the present-day Engelse Kerk).

Page 42
Noorderkerk (Northern Church), Noordermarkt
The remarkable Noorderkerk, built in 1620–1623 and designed by Hendrick de Keyser, is located in the northern part of the Jordaan. The church has an octagonal floor plan and an upper structure in the form of a Greek cross, with four equal arms, that dominates the building. The octagonal form can be seen in the corners of the cross where there are smaller buildings, such as the sexton's house and the church master's

chamber. The design fits well with Protestant worship, where the pulpit takes a central position. The church building underwent extensive restoration between 1993 and 1998. Apart from church services, concerts are also held here.

Page 49
House with the Heads, Keizersgracht 123
The red and white façade of the House with the Heads, built on two plots, is one of the rare examples of the Baroque-Renaissance style, such as can only be found in Amsterdam. City master builder Hendrick de Keyser (1565–1621) designed the building and façade. The rich façade decoration includes vases, obelisks, lion heads and small pillars. At the level of the piano nobile [main floor], next to the windows, there are six heads of gods from classical antiquity, hewn from Bentheimer sandstone. Bentheimer sandstone is used for all of the decorations, including the lower façade. The house was built in 1622 by Nicolaas Sohier, who had amassed a fortune in the hosiery trade. Sohier sold the house to Louis de Geer in 1634. De Geer was a powerfully wealthy man who acquired a monopoly in the arms industry in Sweden via King Gustaaf Adolf. He controlled the entire production process from raw material to finished product. De Geer lent money to the Swedish king regularly and he even had a bust of the king in the hall of his house. The De Geer family lived in the house for four generations, after which it was sold to a series of different owners. Ownership eventually passed to the city of Amsterdam, which had, since 1983, sited the Bureau Monumentenzorg (Office for the Care of Monuments) there. The house was eventually found to be unsuitable as an office building and the city decided to sell the house, amidst strong criticism. It was bought by Joost Ritman, an art collector and businessman, who intends to hold exhibitions and conferences here.

Page 55
Krijtberg, Singel 446-448
Constructed from 1881 to 1883, the Krijtberg on the Singel is a Catholic church that takes its name from the

similarly named warehouse which used to occupy the site. Also known as the Church of Saint Francis Xavier, it was designed by Wilhelm VA Tepe (1840–1920) in the neo-Gothic style, something rarely seen in the Netherlands. The church building was restored extensively from 1997 to 2001.

Page 55

Felix Meritis, Keizersgracht 324

Established in 1776 by affluent Amsterdammers, the Felix Meritis (literally, happiness through merit) society had as its goal the increase of knowledge in the arts and sciences. The society built this colossal canal building, which towers over its neighbours. It was designed by Jacob Otten Husly in the Louis-XVI style. The building houses an excellent concert hall and a beautifully-lit drawing studio. The society fell into decline at the close of the 19th century and the building began to be used for other purposes. Today, it again offers a wide scientific and cultural platform.

Page 60

Stadsschouwburg, Leidseplein

The Stadsschouwburg, both the building and theatre group, was founded in 1618 on the Keizersgracht. When the building was destroyed by fire in 1772, the theatre group moved to a newly constructed wooden building on Leidseplein in 1774. However, this building also went up in flames in 1890. It was rebuilt in 1892, right in the middle of Amsterdam's 'Second Golden Age'. Designed by AL van Gendt and JL Springer, the new building's look suited the grandeur of the times. The building remains to this day. Its interior is, for the most part, still authentic.

Page 62

American Hotel, Leidsekade 97

The architect Willem Kromhout (1864–1940) converted, between 1899 and 1902, the American Hotel from a hotel for the middle-class to a 'Grand Hotel'. For the interior, Kromhout designed, amongst other features, the wall decorations (which can still be seen in some places), the

leaded-glass windows (parts of which still remain), and the furniture. The hotel was extended on the Leidsekade side in 1928 with a new wing designed by Gerrit Jan Rutgers (1877–1962).

Page 64

Museum Willet-Holthuysen, 605 Herengracht

The Museum Willet-Holthuysen is established in a former residence that was built around 1687. In the second quarter of the 18th century, the façade and interior were entirely remodelled to the fashion of the day, but the original floor plan was conserved. The 18th century style of this house was still preserved when the house came into the possession of Pieter Gerard Holthuysen in 1855. His daughter Louise, and her husband, the art collector Abraham Willet, remodelled the stately premises. The Francophile Willet had the interior designed in the style of Louis XVI. The drawing room, known as the *zaal*, was also completely re-upholstered in this style in 1865, as was the garden room on the piano nobile. For his room on the first floor, where he kept his varied art collection, Willet chose a Dutch interior. The rooms were largely unchanged when the house was bequeathed to the city of Amsterdam with the stipulation that it be turned into a museum. In 1896 the premises was opened to the public. The Museum Willet-Holthuysen still bears the air of its last occupants as many of the rooms are filled with the things the couple left behind.

Page 68

**Theater Tuschinski,
Reguliersbreestraat 26–28**

After the film magnate Abram Tuschinski had a quarrel with his architect Hijman de Jong, Tuschinski completed the design himself. The interior and the furnishings of his 'world theatre palace' became as luxurious as the richly decorated exterior. Theater Tuschinski was opened in 1921. From 1998 to 2002 this remarkable theatre was thoroughly restored and the interior was brought back, as much as possible, to its original style.

Page 68

Munttoren (Mint Tower), Muntplein

From 1619 to 1620 a graceful octagonal structure was built upon the base of what was formerly one of the towers of the Regulierspoort (Reguliers Gate). Designed by Hendrick de Keyser (1565–1621), the new tower was adorned with a clock that had a carillon (a set of bells). After 1672 the Regulierstoren gradually came to be known as the Munttoren. This change was tied to the short-lived right that Amsterdam was given in 1672 to mint its own money. The adjacent building dates from 1877.

Page 76

**Nederlands Scheepvaartmuseum
(Dutch Shipping Museum),
Kattenburgerplein 1**

The Scheepvaartmuseum building is a late-18th-century copy of the original 's Lands Zeemagazijn, a building that was constructed at the same site in 1656 by master builder Daniël Stalpaert (1615–1676). By 1740 it became apparent that the 's Lands Zeemagazijn was sinking and heavy supports had to be put in place all around the base of the building. The storehouse was completely burnt out in 1791 but was immediately rebuilt. After the dissolution of the Admiralty in 1795 the navy took over the 's Lands Zeemagazijn and remained the sole occupant until the monument was turned into a museum. The Scheepvaartmuseum was officially opened in 1973.

Page 77

Amstelhof, Amstel 51

Amstelhof is one of the most beautiful—and large—examples of classical architecture in Amsterdam. When it was finished in 1683 it had the widest façade to be found in the city—more than 76 metres long. The complex, which overlooks the Amstel, had housed the elderly poor for a good 225 years. Recently the elderly exchanged their beautifully situated accommodation for a new building. Amstelhof will be rebuilt and become a branch of the Hermitage Museum of St Petersburg (in Russia), with the name 'Hermitage on the Amstel'.

Page 78

Entrepotdok

The Entrepotdok is an enormous warehouse complex that was completed in 1839. Here ships brought goods on which import duties had to be paid. After the remission of these duties, ships were offloaded elsewhere in the harbour. The complex has been converted for residential use and has been lived in since 1984. Small businesses have also established on the ground floors.

Page 81

Muiderpoort (Muider Gate)

The Muiderpoort at the end of Plantage Middenlaan dates from 1770. The former city gate was designed by Cornelis Rauws (1732–1772) in the style of Louis XVI, and is thus classical in design. With the great city extension of around 1900, the gate came to be inside the city and hence lost its function as the entrance to this part of Amsterdam.

Pages 82–83

Stedelijk Museum, Paulus Potterstraat 13

The museum that city architect AW Weissman (1858–1923) designed was, when it opened in 1895, a space meant for the display of a variety of collections. Nowadays the Stedelijk Museum exclusively exhibits modern and contemporary art. The change in use from museum to art gallery made necessary a series of adjustments. In 1938, Director DC Röell and his assistant Willem Sandberg decided to conceal Weissman's Dutch neo-Renaissance interior with a layer of white paint. The wooden wainscoting in the exhibition rooms were also removed and light wall panelling was installed. Over the years, three new buildings were added to Weissman's original. These were demolished to make way for the radical renovation that began in 2004 under the leadership of the architectural practice of Jan Benthem (b. 1952) and Mels Crouwel (b. 1953).

Pages 84–85

Rijksmuseum, Stadhouderskade 42

From 1862 plans were developed to establish an art museum in Amsterdam. After numerous complications, the design of architect Pierre Cuypers (1827–1921) was finally chosen in 1876. The design proposed the construction of a gate-building located in a garden with two identical wings, each with its own internal courtyard. A gateway at street level allowed access to the city for the inhabitants of the, at that time, largely unbuilt Amsterdam-Zuid district. Cuypers gave Rembrandt's *De Nachtwacht* (The Nightwatch) a central position in the museum. In fact, the building was more or less designed around Rembrandt's colossal 3.59 x 4.38-metre group portrait of Amsterdam's civic guard. The façade as well as the interior of the museum was richly decorated with a mixture of Dutch Renaissance and Gothic elements for which a number of artists, both local and international, furnished designs. On 13 July 1885, the Rijksmuseum and its annexe, the Director's House, were officially opened. In the 1920s and 1930s, necessary changes were made within the museum's walls whereby, following the style of the day, many decorations disappeared under a layer of white paint. The interior underwent a large-scale renovation in the 1950s and 1960s when both interior courtyards were fully built-up, thus creating far more exhibition space. However, the result of this was that the new route for visitors to walk inside the museum became disorderly and caused confusion. In recent decades, the calls to return to the simple layout that Cuypers had given the building have been growing. Increasing interest in the art of the 19th century also led to a renewed appreciation for the original decorations. These concerns, along with the need to modernise the museum's facilities, led to the start, in 2001, of an extensive renovation and rebuilding project that is to be overseen by Spanish architects Antonio Cruz (b. 1948) and Antonio Ortiz (b. 1948). The project is scheduled to be completed by 2009, until which time the museum will be only partially open.

Page 86

Vondelpark

The Vondelpark is 'a regal and inalienable gift to the health, for now and all time, for all Amsterdammers, big and small, who are, or are yet to come,' was written in 1901. CP van Eeghen initiated the riding and walking park at the edge of the city and received financial support from other Amsterdammers. In 1865 the first ten hectares were completed, designed by landscape architect ID Zocher. In later years a number of extensions followed. Owing to the city expansion around 1900, the park came to be located in the middle of the city.

Page 88

Van Gogh Museum, Paulus Potterstraat 7

In 1962 the initiative was taken to build a museum that would be dedicated to painter and draughtsman Vincent van Gogh. This was the result of the purchase of the artist's estate by the Dutch state. The land next to the Stedelijk Museum was chosen for the building and in 1963, the architectural practice of Rietveld, Van Dillen and Van Tricht received the commission to design it. One year later, when the project was still no more than a sketch on the drawing table, architect Gerrit Rietveld (b. 1888) died, and two years afterwards so did his partner Joan van Dillen (b. 1930) who had taken over the work. Eventually it was Johan van Tricht (b. 1928) who finished the design. The museum was opened in 1973.

Page 89

Concertgebouw (Concert Hall), Concertgebouwplein 2-6

When the first guests walked into the Grote Zaal (Great Hall) of the Concertgebouw on 11 April 1888, *Einzug der Gäste* from the opera *Tannhäuser* by Richard Wagner was played. Seven years earlier, a group of individuals commissioned AL van Gendt (1835–1901) as the architect on 16 July 1883. With the Neu Gewandthaus concert hall in Leipzig in mind, he designed a building that could best be described, with regard to its style, as 'Viennese Classical'. After the opening, there was extensive experimentation to achieve the optimal acoustics for the great concert hall. This was successfully achieved in 1899 after the adjustment of the height and the slope of the podium. Since that time the hall has been one of the best sounding concert halls in the world. Between 1985 and 1988 the Concertgebouw was thoroughly restored and a new wing was built, based on the design by architect Pi de Bruijn (b. 1942).

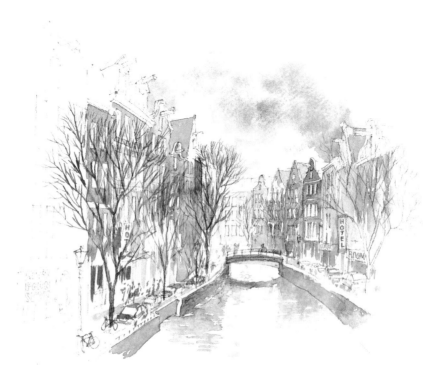

Oudezijds Achterburgwal Canal, Amsterdam